SECRET KENDAL

Andrew Graham Stables

AMBERLEY

First published 2017

Amberley Publishing
The Hill, Stroud
Gloucestershire, GL5 4EP

www.amberley-books.com

Copyright © Andrew Graham Stables, 2017

The right of Andrew Graham Stables to be identified
as the Author of this work has been asserted in
accordance with the Copyrights, Designs and Patents
Act 1988.

ISBN 978 1 4456 6804 8 (print)
ISBN 978 1 4456 6805 5 (ebook)

British Library Cataloguing in Publication Data.
A catalogue record for this book is available from the
British Library.

Origination by Amberley Publishing.
Printed in Great Britain.

Contents

Introduction

Kendal nestles between the Yorkshire Dales to the east and the Lake District to the west, and is affectionately known as 'The Gateway to the Lakes'. If you look at the road network that passed through or emanates from Kendal, the town could have been given the moniker of 'The Gateway to the north-west'. The town is sat on the A6, one of the main historic north–south roads in England before the building of the M6 in the 1960s and 1970s. The A6 currently runs from Luton to Carlisle and is the fourth longest numbered road in Britain. As with any town built on or near a major route, the inhabitants needed to be able to view it, protect it or control it. Kendal is no exception, being a town of four fortresses, an Iron Age hill fort, a Roman fort, an early Norman castle and a later Norman castle. All of these fortifications will have played a role in the protection of this important route and enabled the local lord to monitor the movement of goods and people.

The earliest known inhabitants of the area are believed to be the Setantii or the Carvetii, a pre-Roman British people who it is thought were part of the Brigantes – the Brigantes were the dominant tribe in northern England at the time of the Roman invasion. Although clear evidence for pre-Roman history is hard to find in Kendal, there is an Iron Age hill fort located on the summit of The Helm only a couple of miles south – was this the first Kendal? It was a small defendable settlement, thought to date back as far as 800 BC.

The town is famous around the world for Kendal Mint Cake, a confectionary allegedly produced following a mistake in the preparation of peppermint creams. Due to its high energy content, it was – and still is – used by explorers and climbers, which led to its fame. DID YOU KNOW?

According to early sources, the River Kent has also been known as the 'Can' or the 'Ken'.

Kendal was also the home of Alfred Wainwright, the famous walker and author who lived and worked here from 1941 until his death in 1991. His name is now inexorably linked with the Lake District and the series of wonderfully descriptive walks he published.

Though much of the town has been built over, altered and modernised over the last hundred years or so, there is still a medieval town at its heart. The famous local historian David Starkey believed Kendal could have rivalled York had it not been for the willingness of the town planners to replace the old with new, but Kendal is still a town

of great standing and full of secrets waiting to be discovered. Join the journey through the town as we uncover the stories, buildings and people who make up the character of Kendal, 'The Gateway to the Lakes'.

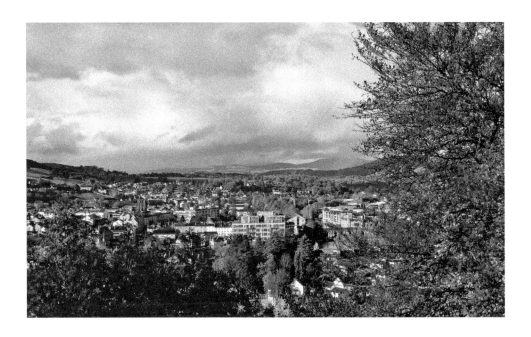

Above: View of Kendal from the castle, a town nestled in the valley of the River Kent.

Right: View of Kendal Castle from the outer ringwork.

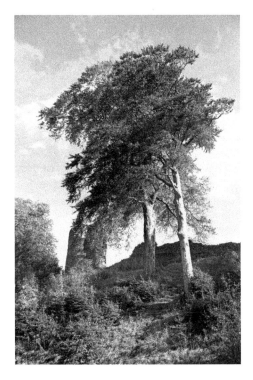

1. A Town of Many Names

Kendal is renowned throughout the country for Kendal Mint Cake and as being the 'Gateway to the Lake District'. Historically it was well known for its great clothing industry, including 'Kendal Green' and latterly as the home of Alfred Wainwright, the much-loved author and fell walker. Now try to imagine the town with a different name, and therefore Mint Cake without the prefix of Kendal. If we believe the pre-Roman population lived at the Iron Age hill fort on The Helm, or at least saw this place as a sanctuary from other hostile tribes, what we do not know is what they called home. Was this land occupied by the Setantii or the Carvetii tribe under the collective name of the Brigantes?

With regularity across the northern counties, wherever there is a hill fort you will find a Roman fort nearby – The Helm is no exception. Less than 2 miles away from The Helm there is a Roman fort nestled in a horseshoe bend of the River Kent. The fort is understood to have been built around AD 95 though the Roman name is still debated, with some calling it Alavana, Alauna or Alunna, but with others unsure if the names Concangium and Medibogodo are the correct designations. Today the site is generally referred to as Watercrook.

Following the Roman military retreat from Britain around AD 411, the remaining Romano-British population would come under attack from the Celts, Picts, Angles and later the Vikings. The post-Roman era was occupied by a number of powerful kings or overlords and became part of the kingdom of Reghed. There is evidence of prolonged conflict and various attempts to fill the power void by local rulers. This was also a time of legends, including Arthur – one of our most enduring tales, but whether he existed or not is not the purpose of this book. This was a time of myths, when history sources are limited, but here we only recognise a time of turmoil left behind by the evacuation of the occupying imperial force.

The kingdom of Rheged covered most of Cumbia, parts of Yorkshire and parts of Lancashire. There were heroic attempts by King Urien Rheged and his sons to hold back the invading hordes but the area was eventually conquered by the Angles based in Northumbria around AD 600. It appears that the Angles settled more in the vicinity of modern Kendal, eschewing the delights of the previous Roman site at Watercrook. Roger Bingham writes that the Angles 'were scared to occupy the ruins of their predecessors because they believed that they were haunted by evil spirits and had been built by giants'. Clear evidence of the Angles' presence in the local area can be seen in some of the place names – like *ham* (meaning 'settlement') – and indeed the current church is built on the site of a much older one. The Angles are also thought to have given the name 'Church town of Kentdale' translated to Kirkby Kendal as it would eventually be known.

It is believed the name Kendal comes from the Celtic word *Can* for the River Ken, or Kent as it is now known. According to Thomas Cox (1731), 'The Waters of this County

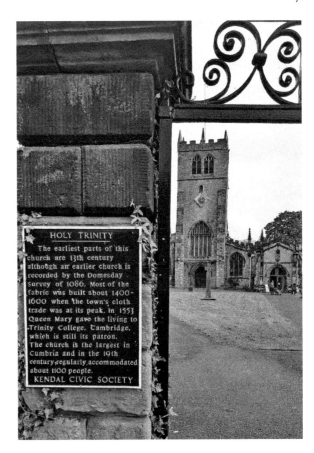

Right: Holy Trinity Church.

Below: Fragment of Anglican Cross in Kendal Holy Trinity Church.

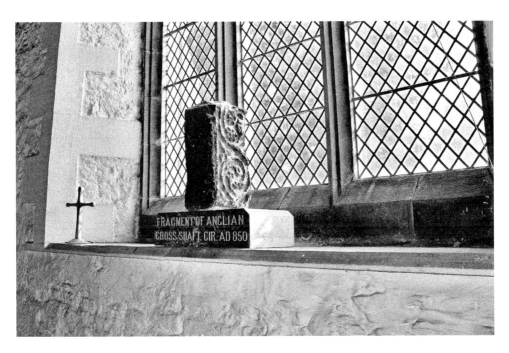

are very plentiful and good. The River Can, Ken, or Kent, rises at Kentmere, and being increased with two large brooks, which join it before it comes to Kendale, they make it a large Stream, with which it passeth to the Ocean.'

The next attacks would come from the ocean when around AD 800 there was further invasion and settlement by Vikings from Ireland, as well as hostile invasion by Danish Vikings. The following years would see a period of attacks and counterattacks between the Vikings and the Anglo-Saxons, especially along the eastern side of the country. Following a successful campaign against the Vikings based at York by Aethelstan in AD 927, the Anglo-Saxon Chronicle tells of a meeting of five kings that took place at Eamont Bridge, just outside Penrith. The meeting was attended by the King of Strathclyde and Cumbria, King of Scotland, King of Wales, King of Northumbria and Aethelstan the King of Wessex, who was to be their overlord. This is generally seen as the date of the foundation of the Kingdom of England, of which Kendal was a part. Owain Caesarius was the King of Cumbria from AD 920–937, and is believed to be buried in St Andrew's Churchyard in Penrith. He would have sworn an oath to Aethelstan as 'Rex Totius Britanniae' or King of all England. In AD 945 the last King of Cumbria, King Dunmail was defeated in battle at Dunmail Raise, near Grasmere, by a combination of King Edmund of England and Malcolm of Scotland. Cumbria was granted to Malcolm I of Scotland in exchange for military support.

With the knowledge of an Anglo-Saxon church site in Kendal and the Domesday Book (1086) mention of 'Stircaland' just to the north of the town, this suggests that the area had already become a settlement long before the borough was founded. The Domesday

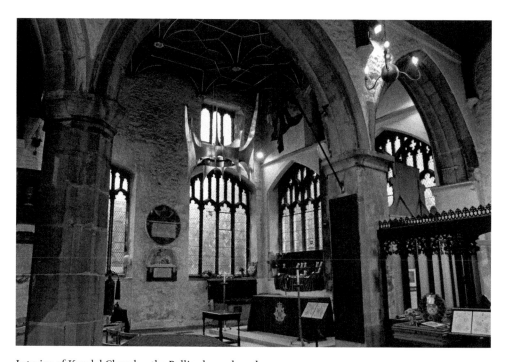

Interior of Kendal Church – the Bellingham chapel.

Book places Kendal or 'Cherchebi' in Yorkshire and is tax assessed as 2 geld units, which is regarded as quite small (a geld was tax assessed per hide, and a hide was the standard unit of land measure). The lands in 1066 are described as being held by Gillemichael, but around 1091/92 the whole of this territory was granted to Ivo Taillebois, a prominent Norman. His descendants took the surname 'de Lancastre' and, following a series of childless marriages, by 1246 the barony was divided between Peter de Brus (d. 1272) and Walter de Lindsay (d. 1271). The Lindsay half of the barony later became known as the Richmond Fee, while the Brus share was further divided to become the Marquis and Lumley Fees.

The barony of Kendal was formed from the following Domesday manors:

'Stircaland'
Stickland Roger & Strickland Kettel, with Staveley, Kentmere, Longsleddale, Bannisdale, Strickland Roger, Strickland Kettle, Crook and Winster.
'Mimet'
Mint: included Mintsfeet and Spittal.
'Cherchebi'
Kirkby Kendal including Kirkland, Nethergraveship, Underbarrow with Bradleyfield, New Hutton and Scalthwaiterigg.
'Helsingtune'
Helsington: including Sizergh.
'Staintun'
Stainton.
'Bodelford'
Now Natland.
'Hotun'
Old Hutton and Holmescales.
'Patun' Patton: included Skelsmergh, Bretherdale and Fawcett Forest, Selside with Whitwell, Whinfell, Docker, Lambrigg, Grayrigg and Dillicar.

In 1189 Baron Gilbert Fitz Reinfrid acquired a market charter for Kendal with this, and the borough charter granted to the inhabitants by his son, William de Lancaster III, at the beginning of the thirteenth century, would have confirmed Kendal as a trading centre. The borough centred on a market place between Stramongate Bridge and the main route up the Kent Valley and may have been linked to the church in Kirkland, as was usual in early medieval market towns. The medieval town would have functioned as the market, religious and administrative centre and would lead to the construction of the castle on the east of the town to replace Castle Howe on the west. The 'new' castle would become the power base and centre for the local administrators.

By now Kendal would be known as Kirkby Kendal, but was spelt many different ways on maps and documents up until the modern day: Kirkbie Kendal, Kirkby Kendall, Kyrkebi in Kendal or even Kirkbie Kentdale are just some of the variations in spelling. Modern day Kendal is made up of Kirkland, Nether Graveship and Strickland townships. The maps available from 1611 to the early 1900s mainly refer to the town as simply

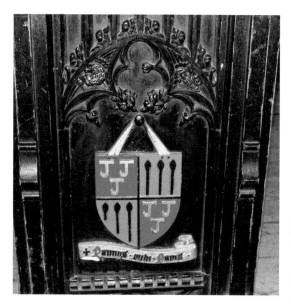

Left: Kendal coat of arms in Holy Trinity Church with the motto '*Pannus mihi panis*', meaning 'wool is my bread'.

Below: Kendal Church contains many historical artefacts.

Kendal, apart from a couple of exceptions in the early 1800s that still used the Kirkby Kendal name. Whatever this place, this land, this town is or was called, Kendal and the surrounding lands are a jewel in the English countryside and perhaps described best by a *Gazetteer* from 1829 describing the Kendal ward as:

> The most interesting portion of the county, both in picturesque beauty and agricultural and commercial consequence; the soil in its numerous dales and thwaites being generally very fruitful, and many of its inhabitants in and around its capital (Kendal) being employed in the manufacture of woollen, linen, cotton, and hosiery goods.

2. The Four or More Fortresses

Castlesteads or The Helm

To the south of Kendal, running parallel to the A65 road, is a promontory hill rising to 185 metres (607 feet) above sea level. This elevated elongated hill is known as The Helm and at its pinnacle is the site of an Iron Age fort. Also known as Castlesteads, this small multivallate hill fort (two or more ramparts) is strategically positioned to command a 360-degree view of the area.

The summit includes an enclosure measuring around 40 metres long by 17 metres wide at the southern end and 25 metres wide at the northern end. The northern side is protected by two earthwork banks separated by a ditch, and the south is secured by a single earth and stone bank. To the east there are traces of a shallow ditch and to the west

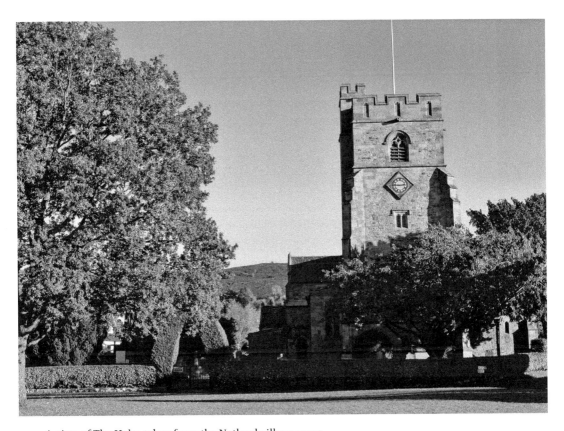

A view of The Helm taken from the Natland village green.

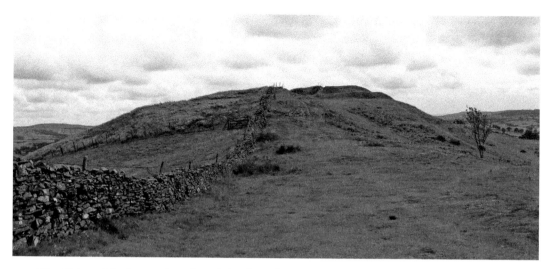

The Helm with the earthworks of the fort clearly visible. (Photo by kind permission of Matthew Emmott)

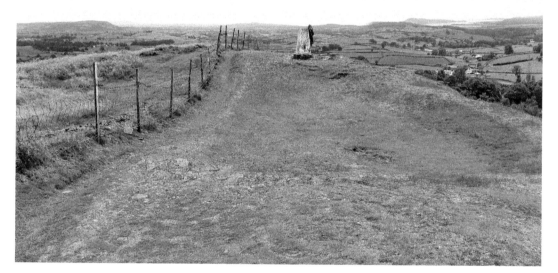

The site of the Iron Age fort from the north. (Photo by kind permission of Matthew Emmott)

a steep edge protects the site. There may have been some erosion or slippage to some defences, especially on the east and west, since the site was in use around 2,000 years ago. It is believed some of the levelled areas within the enclosure may have been hut platforms. The site also includes two rock-cut basins, which may have been used as water collection points to provide the inhabitants with water. The concrete feature at the peak is an Ordnance Survey triangulation station.

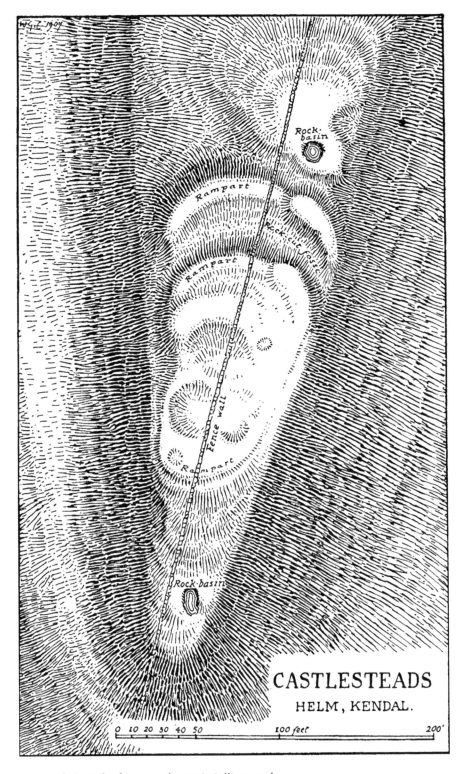

A plan of The Helm from 1907 by W. G. Collingwood.

Watercrook, Roman Fort

Situated below The Helm is a Roman Fort known as Watercrook, which was first documented as Roman in the seventeenth century by antiquarians of the time. They describe brick, plasterwork and a hypocaust still being visible, while later historians and excavations examined parch marks on the ground as well as a civilian settlement (known as a vicus).

The fort is situated in a meander of the River Kent and uses the natural defence it offers on three sides of the fort. Evidence suggests the fort was constructed after the main thrust north from Chester by Gnaeus Julius Agricola, the Governor of Britannia from AD 78–85. Originally it was built as a rectangular timber fort, protected by turf ramparts and a double ditch with roads on each side leading to the four gatehouses or entrances. The roads would have linked to the main roads heading north and south – now the A6 and A65. There is possibly a ford to the north side of the fort, which would have allowed egress and ingress to the main Roman road in the area. The internals of the fort included barracks for the troops stationed here but outside the fort a bathhouse is situated approximately where the farmhouse now stands. Some alter stones were also discovered among the usual finds of pottery and coins, and are now stored at the Kendal Museum. It is believed the fort was rebuilt in stone around AD 139–163 and occupied until late in the third century. During excavations a few finds were found from the mid-third century but

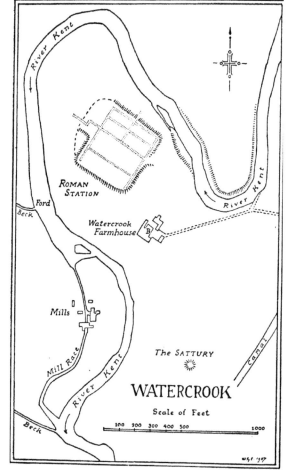

Plan of Watercrook Roman fort and the Sattury by W. G. Collingwood, 1907.

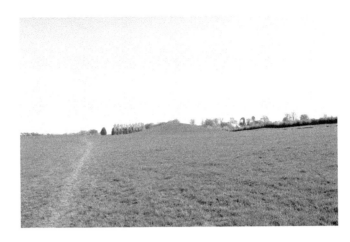

Is the Sattury a Roman feature? (Photo by kind permission of Matthew Emmott)

it is likely the site was abandoned well in advance of the main Roman withdrawal from the country in AD 410. There is some suggestion that the site was subject to flooding and may well have contributed to the early abandonment of the site.

As usual with a Roman fort there needs to be a support network (workshops, pleasure houses, spiritual support, etc.), and a vicus, graves and temple complex will grow up around the garrison to fulfil this role. Evidence for a vicus and graveyard have been found during excavations but to the south stands a mound called the Sattury, the purpose of which is unknown. This mound is possibly part of a temple complex such as those discovered on other sites, or it could be a raised watchtower to warn of attacks from the south or The Helm. Until a more detailed investigation is carried out it is only conjecture as to its true purpose. The Sattury can be seen from the public path but the Watercrook site is on private farmland and would require the owner's permission to allow access.

Castle Howe

On the west of the town and directly opposite Kendal Castle is a raised mound standing to around 11 metres tall and approximately 18 metres in diameter. Castle Howe is generally regarded as the site of an early motte-and-bailey but now forms part of a park and a memorial, having once been used as a bowling green.

DID YOU KNOW?
In August 1786 an earthquake was felt in Kendal. The epicentre was further west, towards the coast, and caused damage at Whitehaven, Egremont and Workington.

Though the exact date for the build has never been confirmed, the most likely period is after the Norman subjugation of Strathclyde around 1092 when William II captured Carlisle. From 1066 the south of the country was taken over by the invading Normans

and they begin to bring the whole country under control. The period 1069–70 has become known as the 'Harrying of the North', but in reality this was a time when various factions were vying for power in the north. This involved a King of Denmark, local Anglo-Saxon forces and Malcolm III, King of Scotland. Following various attacks and counter attacks by the Normans and Malcolm III during this time, the evidence is that Cumberland was still in the hands of the Scots. The Domesday Book, produced in 1086, does not include

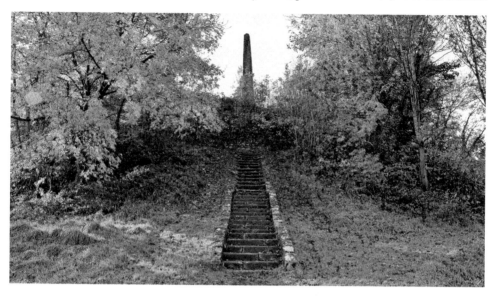

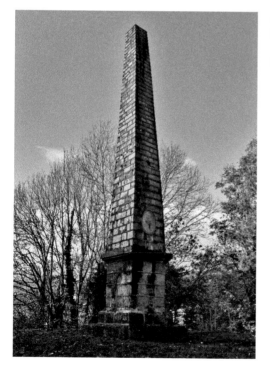

Above: The steps on Castle Howe leading up to the monument.

Left: Castle Howe monument.

the lands now called Cumbria, and it is believed the reason for this is they were not yet under Norman control. However, after another Scottish incursion into England in 1092, William II (the son of William the Conqueror) travelled north and, determined to end the Scottish threat, captured Carlisle Castle. Cumbria was incorporated into England and opened up for settlement by Norman nobles.

The barony of Kendal was given to Ivo de Taillebois, who had supported William during his invasion of England in 1066 and as a reward was gifted the barony of Kentdale, which comprised of huge swathes of land in what is now Yorkshire, Lancashire and Cumbria. Ivo also has connections with Kirkby Londale, Kirkby Stephen, Heversham and Burton in Kendal. Castle Howe is built very much in the style of early Norman earthworks, with a high mound, a large bailey which is surrounded by ditches and wooden fencing. This would point to Ivo as the man responsible for its creation but Eldred, a powerful Anglo-Saxon lord, and his son Ketel may have been entrusted with this part of Ivo's territory. Whoever the overlord was, the site overlooks the river and the old Roman road, so it is well placed strategically to observe and protect these vital routes.

Castle Howe earthworks are still clearly visible.

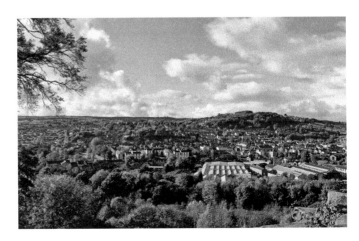

Looking from the castle towards the Castle Howe across the Kent Valley.

Known locally as 'Battle Place' and referred to on Speed's map of 1614 as 'Battail Place', the site also boasted a bowling green on a 1770 map. The Kendal Civic Society believes that Bowling Fell was Kendal's first official park, which was used as a bowling green for a game that would be very similar to boules.

Sat atop the motte is a monument approximately 11 metres high, hewn from limestone with an inscribed tablet that reads: 'Sacred to Liberty, this obelisk was erected in the year

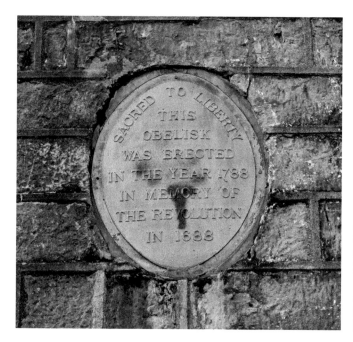

Left: Castle Howe monument plaque with an inscription to the Glorious Revolution.

Below: Kendal Castle, taken from the Garth, the pathway below Castle Howe.

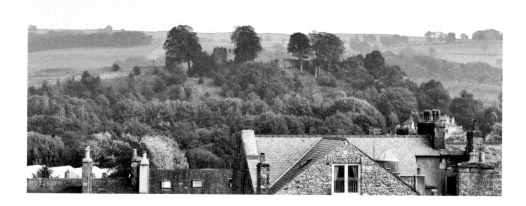

Garth Heads.

1788, in memory of the Revolution in 1688.' The monument was erected by the inhabitants and executed by the benevolent William Holme from the design of his architectural partner, Francis Webster.

Kendal Castle

To the east of the town on the summit of a glacial moraine stands Kendal Castle, a large ringwork dating from the late twelfth century with a thirteenth-century stone castle built within. The impressive earthworks consist of a circular enclosure measuring approximately 76 metres in diameter, which is surrounded by a ditch around 3 metres deep. The ditch is surrounded by an outer bank that is up to 3 metres high and slopes up to the north where the main entrance was once positioned. Originally, this ringwork would have had a timber palisade around top of the enclosure and in all likelihood a timber bridge for access across the ditch into the fort. The centre of the fortification would have contained other buildings to house the soldiers, horses and the lord's retinue.

DID YOU KNOW?
According to Cornelius Nicholson, a large mass of the Kendal Castle curtain wall fell down due to a 'brisk wind' in January, 1824.

One of the many routes to Kendal Castle.

The stone castle is built within this ringwork and consisted of four or more towers, various internal buildings and a curtain wall. The castle would have been entered through a gatehouse on the north side and is shown on an old sketch with a tower on each side of the entrance. Again, buildings are located within the walls, with a hall and cellars to the east of the main entrance and further living spaces within the towers.

Gilbert Fitz Reinfred acquired a market charter for Kendal in 1189 and with the borough charter granted to the inhabitants by Gilbert's son, William de Lancaster III, in the first half of the thirteenth century, this confirmed Kendal as an important trading centre. The market place was at the junction of the route from the north over Stramongate Bridge

with the main route down the Kent Valley. The castle was situated to the east of the river; it was in a good position to offer protection from the north, the most likely point of attack. It should be remembered that Kendal at this time was a border town on a shifting border between English and Scottish control.

It is not known exactly when the castle was built or in exactly what form, but it was probably founded by Gilbert or his son William, who assumed the name de Lancaster in the second half of the twelfth century. It is possible the ringwork castle could be attributed to Gilbert Fitz Reinfred, with William then being responsible for the stone castle in a form more or less as we see today. One local legend has the Scottish raiding the town, forcing the people to seek sanctuary in the parish church at Kirkland and the Scots massacring the townsfolk within. The stone castle may have been built in response to these attacks and to offer a more secure deterrent against further assaults.

Gilbert was also involved in the revolt against King John's extortionate taxation and joined the northern barons in opposition against the king. This was the revolt

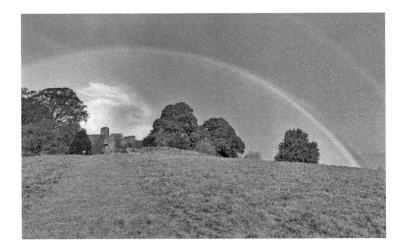

Kendal Castle, looking north.

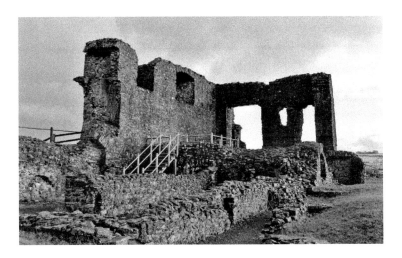

Kendal Castle, main hall.

that led to the signing of the famous Magna Carta, and though Gilbert was not one of the twenty-five barons who sealed the 'Great Charter', he was probably present at Runnymede on 15 June 1215. When John later reneged on the deal, Gilbert played a part in the final opposition to John when he was taken prisoner after the siege of Rochester Castle. Gilbert was imprisoned for being part of the rebellion and documents tell us that Kendal Castle was surrendered to the king as part of the 12,000 marks ransom demanded for this disobedience. By 1241 the castle was returned to Gilbert's son, William de Lancaster.

When William de Lancaster died without an heir in 1246 the title of Baron passed to Peter de Brus, who also died without issue. The barony passed to the de Ross family until 1390 when it went to the Parr family, whose descendant was a Sir William Parr (1513–71). The Parr family are most famous for a queen, Katherine Parr, who was the last wife of Henry VIII. Though local legend says Kathrine Parr was born at the castle, evidence suggests she was actually born around 1512 in her father's house in Blackfriars, London, and the castle went unlived in for many a year. The castle is described in 1572 as 'all being in decay … and in all other reparations needful.'

The Owners of Kendal Castle in Brief:
1180–1272: Lancaster Barons of Kendal.
1272–1390: de Ross Barons of Kendal.
1390–1572: Parr family Barons of Kendal.
1574–1667: The Crown.
1667–1896: Various families.
1896–1974: Kendal Corporation.
1974–present: South Lakeland District Council.

From the 1570s the castle deteriorated further with stolen slates, timbers and stones. The remaining materials were sold off to leave nothing but a shell of its former glory. Various maps, drawings and paintings show the castle as ruinous over the following

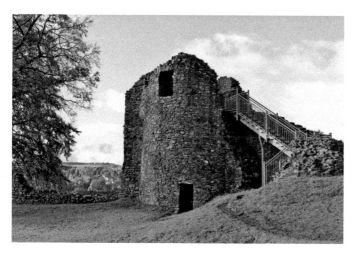

Kendal Castle, West Tower.

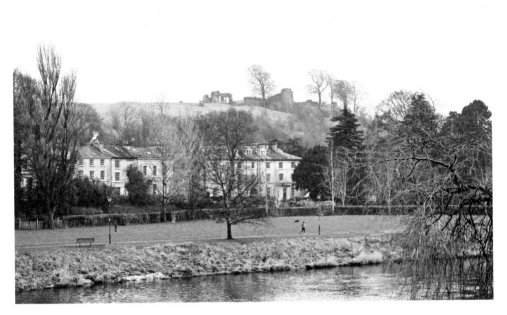

Kendal Castle, Gooseholme and the River Kent.

years, until some repairs were carried out in the early 1800s. These 'repairs' may have caused more harm than good, especially as some trees were also planted on the site and the in situ stones were used to repair a vision of how they felt the castle should look. The grounds were also used as grazing land, partly landscaped and as a camp for local militia.

By the time the Kendal Corporation purchased the castle in 1896/7 the historic site would be very different from its heyday in the medieval period. As part of Queen Victoria's Diamond Jubilee the grounds were opened as a public park, and, following the 1974 boundary changes, the castle and grounds have been in the care of the South Lakeland District Council.

Four or More Fortresses

The title of this section is 'Four or More Fortresses' because in addition to the four obvious forts described above, there are a number of other possible sites in the vicinity and cannot be dismissed as being forts until they have been fully investigated. Some of these features could be natural, railway work spoil heaps or actual defensive positions.

To the east of the town is Hay Fell. Here various antiquarians refer to Coney Beds as a fort located 'in the field immediately above the house called High Park' and 'before the enclosure in 1814, its vallum and fosse were very perfect, inclosing a bell-shaped area'. This fort, suspected as Roman, covered an area of almost 2 acres and is also thought to be a place where farmers would leave their goods for the inhabitants of Kendal during the times of plague.

Other potential 'motte' sites are identified at Round Hill, Birds Park Farm and Castle Green. These are situated to the east of the town where Round Hill is administered by the Woodland Trust and can be accessed via some steps off Sedbergh Drive. Birds Park Farm 'motte' can be seen from Sedbergh Road, and Castle Green 'motte' is a tree-topped mound visible from Castle Green Road.

To the north of the town, surrounded by a housing estate, is another possible 'motte' of some several metres high and extending between Low Garth and Kettlewell Road. A definite circular site and unlikely to be a drumlin (glacial feature), the mound has been left fallow and is still accessible from the estate.

Left: Possible motte located off Kettlewell Road.

Below: Another view of the mound – man-made or natural?

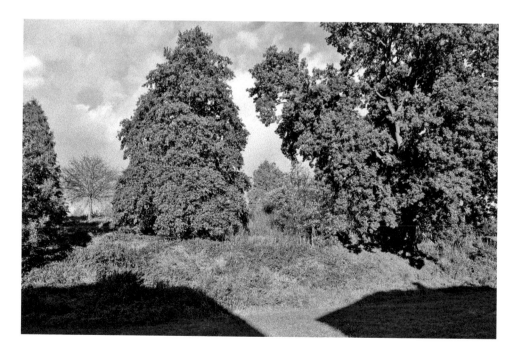

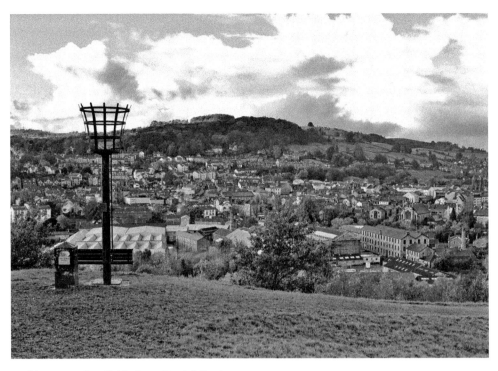

Looking towards Fellside from Kendal Castle.

Looking south from Kendal Castle towards The Helm.

3. Plague, Famine and War

During the medieval period Kendal was subject to famine, Scottish raids, and bad harvests. One of the worst raids recorded was in 1322, when the armies of Robert the Bruce attacked the northern counties and Edward II was almost ineffectual in stopping them. It was noted that some properties in Kendal were still lying empty two years after the attacks. Previously, in 1315 and 1317, there was a sheep murrain (an old term for disease) and bad harvests, which led to a great famine.

Later, at the end of the sixteenth century until halfway through the seventeenth century, the north-west of the country suffered plague, famine and civil war on an unimaginable scale. There is evidence from the records from the barony of Kendal that tenant numbers peaked by around 1560. The population in 1576, based on accounts at the time, is estimated to have been around 2,200–3,200, yet 100 years later the population was almost unchanged. The lack of population growth during this period can be explained by a series of catastrophes that beset the region. First of all the area was hit by a devastating outbreak of plague in 1597–98; though there had been outbreaks before, this one was considered particularly overwhelming. There is a brass plaque in St Andrew's Church, Penrith, recording 2,500 deaths in Kendal, 2,260 in Penrith, 1,196 in Carlisle and 2,200 in Richmond. The source of the figures is unknown but may represent each of the complete boroughs or deaneries. However, a document headed 'Corporacion of Kirkbye Kendall' numbers those that 'dyed of the Infectious syknes' at the time as follows:

Highgate 500
Stricklandgate and Marketstead 326
Stramongate 400 and beyond the bridge as 160
Kirkland 245

This totals as 1,631 who died of the sickness, and the effect on the community must have been huge. The markets and business were badly disrupted and social gatherings such as marriages and baptisms were suspended. Along with all the fear and tragedy, taxation needed to confine the infected in newly built isolation houses on the Fell and to pay watchmen to keep them or check on their demise needed to be raised. Rents were not being paid and collecting further taxes must have been another burden to be endured. Apparently the corporation was still trying to collect rent arrears from 1598 to 1614.

The plague had visited the area before this outbreak but this is the best recorded event, and it has been more recently suggested that the epidemic was not spread by rodents as usually thought. Duncan and Scott are convinced the disease was not bubonic plague, carried by the fleas that lived on rats, but another highly infectious and deadly virus

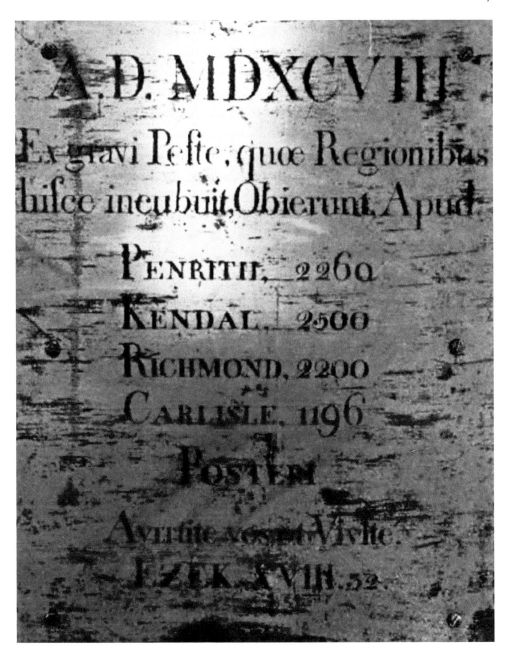

Brass plaque in St Andrew's Church, Penrith, recording deaths from the plague.

called haemorrhagic plague. They argue that the rapid rate with which the Black Death spread could not have been sustained by a flea-borne plague. The Black Death spread around 30 miles every two to three days according to the experts, but bubonic plague moves much slower at a rate of only 100 yards a year. A person-to-person transmissible virus such as Ebola would have been able to spread at the rate recorded.

Though the initial effect of the plague was devastating and the population took time to recover, there is evidence that the people enjoyed a period of some prosperity. Harvests still needed to be gathered and the local industries needed labour, and, due to a reduced workforce available, wages increased. But this upturn in fortunes was not to last, and within twenty-five years another disaster was to strike the region.

DID YOU KNOW?
When the plague was at its height in the summer of 1598, the town corporation appointed men to keep 'cripples' out of Kendal.

In 1623 parts of England were struck by a major famine that would bring further misery to a beleaguered people. Following a record poor harvest in 1622, the following year resulted in high wheat prices and low sheep prices, which led to famine in the area. Though mainly contained to the north-west of the country, Cumberland, Westmoreland and Dumfriesshire suffered particularly and there was a significant rise in burials at this time estimated to be around 20 per cent of the population. The plague had taken an estimated 40 per cent of the population but followed by this latest tragedy was unprecedented.

Most of the country appears to have been stricken by the famine, but extensive starvation was generally confined to the upland north and west. Even in parts of the lowland east of England the situation could be desperate. One Lincolnshire landlord reported how one of his neighbours had been so hungry he stole a sheep, 'tore a leg out, and did eat it raw'. 'Dog's flesh', he wrote, was 'a dainty dish and found upon search in many houses'. The famine was noticeably worse in the highlands of the north-west, even in Lancashire it has been calculated that famine killed around 5 per cent of the population. In parts of Cumberland and Westmorland there were reports of the poor men, women and children starving to death in the streets.

The famine of 1623 is recorded as the most significant in English history and though it returned every decade or so, it never again resulted in such widespread mortality. There were reports of famine in Cumberland and Westmorland in the late 1640s, possibly during and because of the Civil War. There were further spikes in the death rate around 1727–30 when repeated outbreaks of disease coincided with two bad harvests. But 1623 was the real defining moment, and can be classed as England's last real famine.

The next hardship the people of Kendal had to endure was the English Civil War, a dispute between king and Parliament that lasted for over nine years from 1642. The conflict dragged in men of importance as well as the common man, who fought by conscience or the beliefs of their lord and master. There were very few supporters of Parliament in Cumberland and Westmorland, with the Briscoes, the Ponsonbys and the Briggs being in the minority. The Royalist families included the Curwens, Huddlestons, Lowthers, Lamplughs, Musgraves and Senhouses – in other words, all the significant houses of the region were firmly on the side of the king. The Stricklands from Sizergh

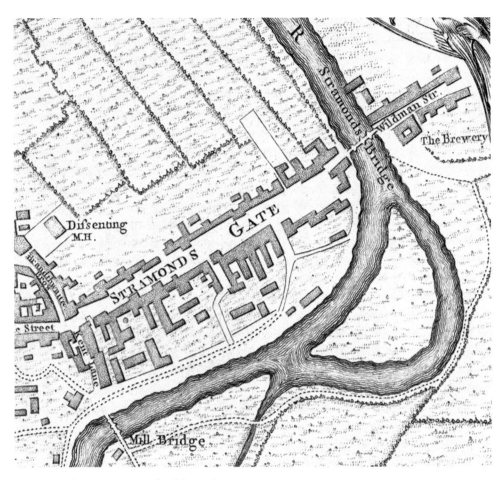

1770 map of Stramongate and Wildman Street.

were actively Royalist, with Robert and his son Thomas commanding a regiment of horse and of foot.

It is suggested the Cumberland and Westmorland had a general malady and a reticence to become too involved in the conflict. There was a desire from the great families from the area to protect the county against aggression but not to venture out and risk leaving their estates defenceless. It is also said the muster produced a low quality and poorly armed militia of 'small number'. Kendal was one of two places in the county who controlled powder magazines (the other at Appleby) and were, according to Waytes, 'well stored' with 'powder and match, besides a supply of lead for bullets'. Therefore, some level of protection would need to be placed on this cache of weapons and ammunition.

Kendal did not feature in any significant battles during the English Civil War but was a key town on the western route into the heart of England. Known as the Second Civil War, Charles I negotiated a secret treaty with the Scottish 'Engager' group, where he agreed to impose Presbyterianism in England if they would raise a Scottish army and restore him to the throne. Sir Marmaduke Langdale seized Berwick for the king on 28 April 1648

and the very next day the local Westmorland and Cumberland commander, Sir Philip Musgrave, captured Carlisle. This action secured the routes into England for the Duke of Hamilton's Engager army, who intended to drum up support from the local Royalists and swell their numbers as they headed south. The poorly organised Royalists did not march into Cumberland until 8 July and were poorly equipped. They were also relatively low on numbers too. The Duke of Hamilton had 6,000 foot and 3,000 horse and were reinforced by Langdale, who had raised 3,000 foot and about 600 horse.

There was not the expected support from an area that was predominantly Royalist, and the Duke of Hamilton dallied for a month in the north waiting for further numbers from Scotland. They were further reinforced by a contingent of 3,000 veteran Scots from Ulster and commanded by Major-General Robert Monro. The numbers of the Engager army were now swelled to around 18,000 men, rapidly becoming notorious for violence, plundering and unruliness.

Major-General Lambert commanded the Parliamentarians in the north and for a time quartered his troops at Penrith Castle. At the time the main army under Cromwell and Fairfax was held up at sieges in Pembroke and Colchester, so with only a few thousand horse at his disposal, Lambert harried and harassed the Royalists. Hamilton took Penrith and Appleby and Lambert withdrew across the Pennines to Barnard Castle to block the route into Yorkshire and to prevent a link up with Royalists at Pontefract Castle.

Kendal was taken over by the forces of General George Monro when the town billeted around 3,000 well-trained and experienced soldiers. When the Hamilton's force moved south towards Kendal on 29 July 1648 he rode into the town to meet Monro, where it was decided that Monro and his forces should follow at Hamilton's rearguard to Kirby-Lonsdale. The Scottish army decided to move south, but were divided both on course of action and geographically with Hamilton's foot at Hornby, Langdale scouting in Lancashire, Calander and Middleton's horse at Wigan, and Monro's force protecting the rear. The problem the Engager's now faced was that Oliver Cromwell had broken the siege at Pembroke and was on his way to Yorkshire. He joined up with Lambert at Wetherby on 12 August to bring the Parliamentarian army to around 9,000 men. By 14 August 1648 Cromwell and Lambert were at Skipton, heading towards Preston. The Parliamentarians attacked on 17 August and Oliver Cromwell, with his first full command of the army, defeated the Scottish forces at the Battle of Preston. Further skirmishes followed at Wigan and Winwick Pass on 19 August 1648, but by the 28 August the insurrection was over with the end of the Colchester Siege. Within six months of this defeat Charles I was tried and beheaded, making the country a Republic – known as the Commonwealth – for the next ten years.

Only three years after Preston, Kendal was to become a haven for the Royalists again. Charles II invaded the Commonwealth and crossed the border at the head of another Scottish force. Once again the hope was that the English would support his cause, but memories of the violent plundering from the Engager invasion of 1648 enabled Parliament to mount an effective propaganda campaign to stimulate anti-Scottish feeling. Oliver Cromwell was advancing on Perth in Scotland when Charles II and David Leslie with a Scottish army of 14,000 troops crossed the border into England on 5 August 1651.

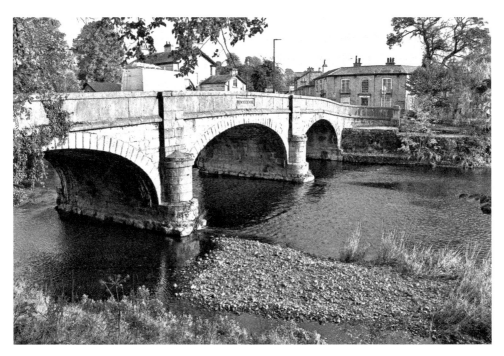

Miller Bridge, previously called Mill Bridge.

At the beginning of the march, the discipline was excellent, and just a week after setting off from Scotland they managed to cover 150 miles. By 8 August the army took a well-earned rest between Penrith and Kendal, but, once again, Cromwell had chosen Lambert to pursue and harass the invading army yet not to engage. On 9 August, Charles was at Kendal with his retinue and Lambert was keeping a close eye on the Scottish movements. On 12 August 1651, Charles II is recorded as being at Ashton Hall without 'pomp or splendour' as he continued southwards to the Worcester.

As the advance continued, David Leslie became more and more pessimistic as the expected support did not materialise. When Charles occupied Worcester on 22 August the army was still less than 16,000 troops. Even when support was brought to the field they were harassed or defeated by the forces of Parliament. The Earl of Derby and Sir Thomas Tyldesley raised a Lancashire force but were defeated by Colonel Robert Lilburne at Wigan on 25 August. Tyldesley was killed in the action and the further hope for the Royalist cause began to fade. Now facing a Parliamentarian army of over 28,000 men, when the assault started on 3 September the Royalist defeat was inevitable. Charles was once more forced into exile, having spent weeks after the battle evading capture. He moved from safe house to safe house, often in disguise and having famously hiding out in an oak tree. He eventually made it to the coast and escaped to France, not setting foot in the country again until the Restoration in 1660.

One of the more bizarre results of the Civil War or just after was purported to have occurred in Kendal Church. At the conclusion of the war there was still deep divides and animosity throughout the land and some abuses of power among the victors. Two families

The helmet and sword
of Robin the Devil in
Kendal Church.

on the opposing sides were the Briggs's and Philipsons – they were possibly related but were still bitter enemies. Colonel Briggs resided at Kendal and was both a leading magistrate and an active commander for the Commonwealth. During the Civil War the Philipson family served the king; Huddleston the elder had commanded a regiment while Robert was a major. Reportedly, he was a 'man of great spirit and enterprise' and a brave combatant, earning the nickname Robin the Devil from the Parliamentarians.

The story tells us that Robert was angry and humiliated by an attack on his home where he had endured a period of siege. Full of revenge, he rode to Kendal with a small troop of soldiers and headed for the parish church where Colonel Briggs was at prayers. He rode straight into the church and tried to attack Colonel Briggs but the congregation are supposed to have stopped him in his intent to harm the Colonel. Some accounts tell of him hitting a beam on the way out and knocking his helmet off, whereas others describe him having his girths cut, being unhorsed and seized.

Also known as 'the Rebel's Cap', there is a helmet and sword still displayed on the church walls. The helmet is actually a Tudor Morion (steel helmet) and unlikely to have been worn during the Civil War, but there is a tomb in the Bellingham chapel of Kendal Church for Sir Roger Bellingham, who died in 1533. It is more likely the helmet and sword are linked to this tomb rather than the Robin the Devil story.

The next conflicts to affect Kendal were the 1715 and 1745 Jacobite Rebellions. These were attempts by the Catholic Stewart dynasty to retake the crown following the ousting of James II of England during the 'Glorious Revolution' in 1688. To maintain the Protestant bloodline, William of Orange and his wife Mary, who was the daughter of James II but a Protestant, were installed as the monarchy. In 1715 James II's son, James Francis Edward, Prince of Wales, nicknamed the Old Pretender, was approaching Penrith with the Jacobite army. The Bishop of Carlisle had assembled a Cumberland and Westmorland militia to the north of Penrith but the poorly armed militia fled the field and the Jacobites stayed in Penrith before moving south.

On 5 November the army marched for Kendal and by around noon six quarter-masters arrived, followed by Brigadier Mackintosh, who was lodged at Alderman Lowry's house

The 'Cauld Stean' used for proclamations in the town.

in Highgate. Later in the day the army arrived in pouring rain with 'no swords drawn or colours displayed, only six highland bagpipes played them in'. At the Cauld Stean, in Stricklandgate near the marketplace, they proclaimed for James III. The stone (Cauld Stean) is now displayed outside the town hall and was generally used for proclamations.

Various senior lords and generals were housed throughout the town, and some Kendal officials were held for not revealing information regarding the militia. There was no great abuse of the local population but apparently some troops broke into the church expecting to find weapons and powder stored there. The next morning, after a short march, the army reached Kirkby Lonsdale. On 7 November they headed for Lancaster but the cause did not pick up support as expected, and over the next few days at the Battle of Preston they were defeated – the rebellion was over.

In 1745 Prince Charles Edward Stuart, son of the Old Pretender, also known as Bonnie Prince Charlie, raised the Jacobites again and, following early successes, they headed south towards London. He is recorded as residing at Penrith during the advance south, passing through Kendal and making it all the way to Derby. Not knowing the road to London was relatively clear, they began to lose their nerve and, after some deliberation, turned back for home. During their retreat north on 13 December, 100 horse of the Duke of Perth reached Kendal and because it was a market day there was a mob of local people at

the rear of his troop. As they turned down the Fish Market, one of the rebels was killed by a musket shot fired from a window and the people took two other soldiers as prisoners. The Jacobites returned fire and John Slack, a respectable farmer, was killed with two others being seriously wounded. Following the fracas the people dispersed and the troops proceeded to Shap. Though a record from a *Gentleman's Magazine* of 1746 records how they 'entered Kendal and passed quietly till they came into Finkle-Street, where the mob suddenly rising fell upon them, with clubs, stones or anything they could pick up in their hurry'. The account goes on to say the troops made a short stand below the Fish Market and four people received fatal wounds. They state that no rebels were killed but four were taken prisoner and the rest chased out of town by the enraged people.

The main Jacobite army was strung out and pursued by the government army under the command of the Duke of Cumberland. Prince Charles Edward Stuart is said to have stayed at what is now Charlie's Café Bar, though at the time the house in Stricklandgate was owned by Justice Thomas Shepherd. Bonnie Prince Charlie slept here overnight and the following night the Duke of Cumberland occupied the same bed.

The government army pursued them until Clifton, a village just south of Penrith, where they clashed. The encounter is only designated a skirmish, but the Battle of Clifton Moor on 19 December 1745 is claimed to be the last battle on English soil. The losses were light, with around twelve Jacobite soldiers killed and the government dragoons losing ten men. The retreat north continued until the final collapse of the clans at Culloden in April 1746.

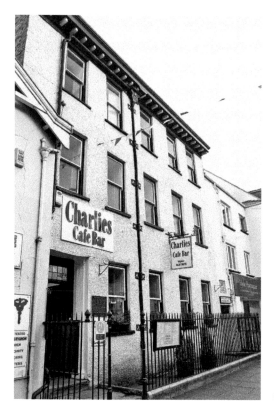

Charlies Café Bar.

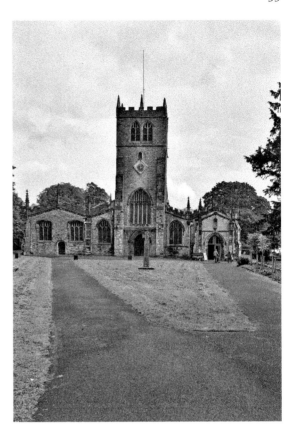

Kendal Trinity Church contains
the Border Regiment chapel.

It is amazing how a more Italian than Scottish Catholic Prince, who believed in the
divine right of kings, is such a romantic story and yet hardly anyone will have heard of
the protestant Duke of Cumberland who actually defeated this band of rebels. The Duke
and his government troops, who included Scots, no doubt saved the country from further
hardship and bloodshed under the unlucky Stewart dynasty.

Chinese Flag

Within a cabinet in the Border Regiment chapel of Kendal Church is a Chinese
flag captured the Battle of Tinghai. The 55th Regiment of Foot served in the First
Anglo-Chinese War (1840–42), arriving in China in 1841 and took part in the Battle of
Amoy on 24 August. They were the first to land on the beach during the Battle of Tinghai
on 1 October and assaulted an enemy position under heavy fire. Taking the heights over
Tinghai, they immediately descended to place their colours on the city walls and earned
huge praise for their actions. Following further action during the battles of Chinhai,
Chapu and ChinKiang Fu, they remained here until the Treaty of Nanking was signed,
with some of the regiment remaining in Hong Kong until after the war.

For its service during the war the regiment was awarded with the addition of a dragon
badge with 'China' inscribed on its regimental colour. The dragon is also used on their
buttons, badges and other regimental insignia.

4. Transport and Industry

The early economy of Kendal is derived from its right to hold markets at the heart of a rural community with established communication links. This right was granted in 1189 by Richard I, and later confirmed by Edward II, Edward III, Elizabeth I and Charles I. The current street market takes place on a Wednesday and Saturday, with the indoor market open six days a week.

As a manufacturing town at the centre of a rich agricultural area, the influx of people on market days would have stimulated the local economy. Kendal would have been a vibrant melting pot of people from around the South Lakeland area. The town population would increase further during the two yearly fairs sanctioned by the Charles I charter to be held 'on the eves, days, and morrows of the feasts of St Mark, and St Simon and St Jude'. The 1829 *Gazetteer* mentions four annual fairs in March and April, and two days in November – one for cattle and one for horses.

Bull-baiting took place in Kendal until it was discontinued around 1790, and the butchers would rarely slaughter a bull unless it had been publicly baited. The bull ring was traditionally placed on the green at High Beast Banks, but there was another custom sometimes applied to the ring on market or fair days. If someone took hold of the ring and shook it, this was tantamount to throwing down the gauntlet as a challenge to fight 'not unfrequently done by pugnacious fellows, on fairs, and market days'.

As the market grew over the years, parts of the town or public houses would become the centre for the different trades, with the Shambles being the area for butchery. At the top of Finkle Street was a fish market and there was the horse market in New Road. Corn was sold in the old market hall and potatoes and vegetables in Stramongate.

The 1829 *Gazetteer* also describes the great improvement in agriculture since the turn of the century and the increase in production of wheat and other grains. Siting the enclosure of the commons and the use of lime as manure as the reasons, they comment that thirty-five years earlier 'no wheat was exposed here for sale, and 30 loads of oats was considered a full market.' Now 'it is not uncommon to see 200 loads of wheat, and a much greater quantity of oats and other grain in the market.'

Further trade was brought to the town by the building of the canal, which was completed in 1819, and an example of this is the office of the Corn Inspector was moved from Burton to Kendal. Records from 1823 state that during the previous year 16,241 sheep, 4,278 calves and 1,578 cows were slaughtered here. Apparently the custom of making pies of minced mutton mixed with fruit and sugar in the Christmas season was so prevalent that on every 24 December from 700 to 1000 sheep were slaughtered for this very purpose. Now, of course, we enjoy our mincemeat pies as mixed fruit and spices, without the actual meat.

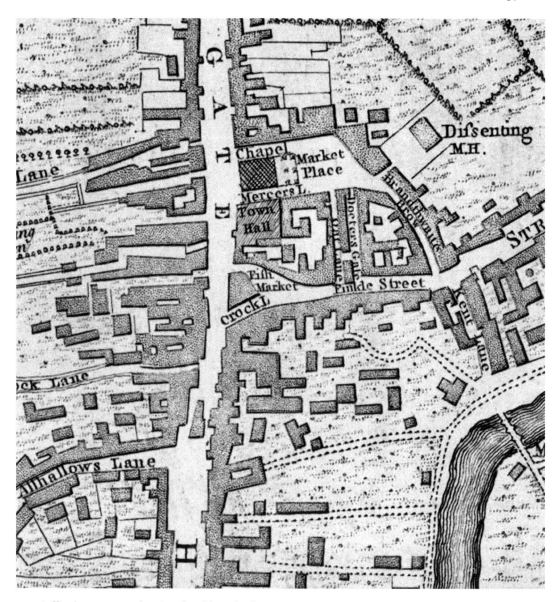

Jeffrey's 1770 map, showing the old market layout.

Transport around the area had historically been by using the old packhorse routes, but as industry grew the need to move people and goods efficiently was essential for trade. This need to improve transport links led to a period of road building. These new roads, known as 'turnpikes', were managed by consortiums of businessmen and their upkeep was paid for by tolls. In a period over twenty years from 1751, nearly 400 new turnpikes were sanctioned throughout the country and many existing roads improved.

Kendal was clearly a major crossroads in the area, with major roads passing north to south, east to west and linking to other key towns in the area like Appleby, Kirkby Lonsdale, Ambleside, Orton and Kirkby Stephen.

Local Turnpikes and Dates
Kendal–Ambleside: 1762.
Appleby–Kendal, Orton–Shap and Tebay–Brough: 1761.
Kendal–Sedbergh: 1762.
Heronsyke–Eamont Bridge: 1753.
Milnthorpe: 1759.

The Jeffery Map (1770) shows a toll house located close to Nether Bridge on the A65. This would have been inhabited by a pikeman and he would have had a clear view of the road as well as a display area for the toll board detailing the cost of the road use. There is another building known as the Old Toll House on the corner of Burton and Natland roads (now a roundabout), and another on the Appleby Road in Scalthwaiterigg. Many of these old toll houses are scattered throughout Westmorland and are now used as domestic dwellings.

In the eighteenth and nineteenth centuries the west coast ports like Liverpool, Lancaster and Maryport were at their peak of prosperity. Trading in coal, cotton, wool and tobacco led to prosperity and a rapid growth of towns like Liverpool, Manchester and Leeds, with

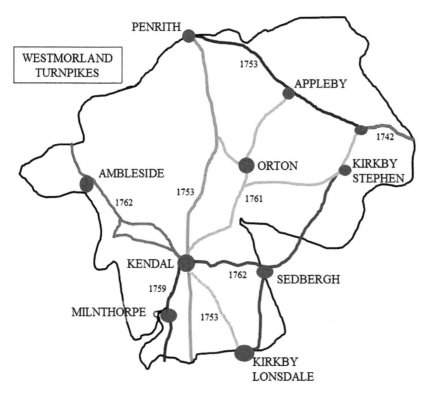

Map showing turnpike opening dates.

River crossing at Stramongate.

Canal Head buildings.

Lancaster only a few miles downriver of Kendal, where there was already an established cloth industry and a burgeoning snuff and tobacco business. To compete with Liverpool the Lancaster merchants proposed building a canal. This waterway would start in Kendal, run due south through Lancaster and join up with the Leeds & Liverpool Canal.

The canal was surveyed by several engineers over the following years, James Brindley (or his pupil Whitworth) and John Rennie had looked at different routes. The goal is to ensure the canal can transport all the valuable cargo from the region and must combine economic construction routes while ensuring all these sources of revenue are serviced. Rennie's final proposals were accepted by Lancashire and south Westmorland and an Act of Parliament was obtained. Construction began in 1792 and was beset by financial problems resulting in delays until 1819 when the canal was finished at Kendal. In 1826, this included a section to Glasson Dock, south of Lancaster and near the mouth of the Lune Estuary.

DID YOU KNOW?
Kendal was famed for its cloth making and is even mentioned by Shakespeare? For several centuries buckram made at Kendal was the common clothing of the poor in London and other cities. Falstaff from *Henry IV*, Part I says, 'But as the Devil would have it, three misbegotten knaves in Kendal green came at my back.'

Initially the canal thrived by carrying all manner of goods but, as with the rest of the countries waterways, the demise was not far away due to the onset of the railways. Once the railway system became more than local links and expanded to become a network, connecting all the major cities and ports, the canals struggled to compete. By the 1860s the canal was leased by the London & North Western Railway until it was bought by them in 1885.

The canal had always suffered from leakage due to limestone fissures and the sections around Kendal were closed in the early 1940s, and in 1944 the last consignment of coal was carried from Barrow via Glasson Dock to Lancaster. The section from Kendal to Stainton was gradually closed, dewatered and filled in from 1947, but the route of the canal south from Kendal is still clearly visible, with most of the bridges remaining in place. The Kendal Canal walk starts at Canal Head and stretches south for 14 miles, and includes fifty-two structures along the route.

Cumbria has long been a county known for its wool industry and after the Norman Conquest the abbeys across Yorkshire, Cumbria and Lancashire were responsible for hundreds of granges and tenant farmers who were rearing sheep and exporting wool. After the Dissolution of the Monasteries between 1538 and 1541, the wool production came under the local landowners via the king's favour or grants. Local production of cloth was encouraged and the growth of what was just a cottage industry began to flourish.

Trades now lost to us would include fellmongers, who disentangled the wool; bowkers, who would clean the cloth; and fullers, who would spend the day trampling the wool in a

barrel of stale urine to produce a softer cloth. Many of these trades from history have become surnames and may indicate your ancestry – not so exciting for the Fullers, I would imagine.

Kendal had a prominent role to play in the industry and had a cloth named after the town. Kendal Green 'is first dyed a light blue using either indigo or woad, then over-dyed in a 2nd dye bath with a yellow such as weld of dyer's greenweed with a mordant such as alum added'. Kendal produced many cloths over the years including Kendal cloth, Kendal cottons, duffel, kelters and chamlett, to name but a few.

It was so much in fashion in the reign of Henry VIII that the king and his nobles would sometimes appear in disguise as Robin Hood and his men 'dressed in Kendal with hoods and hosen', according to Holinshed's Chronicles. In 1770 upwards of 3,500 pieces of Kendal cotton were sent to Liverpool for exportation to New York, Jamaica, Barbados, Dominique, St Kitts, Newfoundland, Carolina, Virginia and Maryland.

DID YOU KNOW?
Before turnpike roads were around, over 300 packhorses were employed in transporting the merchandise of Kendal alone.

Various maps show the area of Gooseholme as an island in the middle of the Kent – now a park area. The river was diverted around Gooseholme towards Little Aynam and towards the Castle Mill where it turned waterwheels. Small bridges accessing the land were built, and at the height of the cloth industry this area was used as 'tenter grounds'. These were where large frames with sharp hooks on top were used to stretch the finished cloth, and some maps actually show the frames. The river was widened after a flood in 1954, and the 'mill race' was filled in at the same time.

During the eighteenth century the cottage industries gave way to the larger woollen mills made possible by the spinning jenny and other advances in technology. The real peak for these trades was in the nineteenth century, but Kendal was now competing with some of the larger cities in Lancashire and Yorkshire. By the 1930s competition from abroad and the new artificial fibres struck the death knell for the industry. The long tradition of cloth making can be seen in the town motto *Pannus mihi panis* meaning 'Wool is my bread'.

Above: View of Gooseholme, once an island used as tenter grounds.

Left: Snuff has been produced in Kendal for over 200 years.

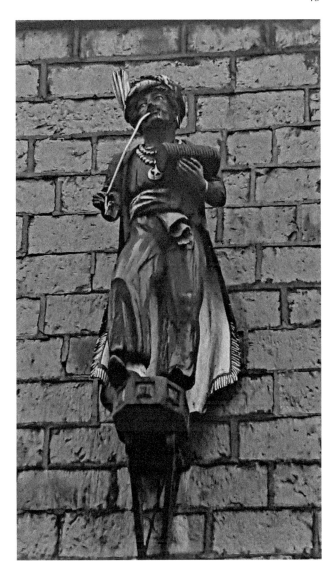

The Saracen in Lowther Street.

Kendal is also known for snuff manufacture, confectionary production and shoe making. The shop K Shoes was founded by the Somervell family in the nineteenth century and at its peak employed 20 per cent of the working population of Kendal. The business began to decline in the 1970s due to changing markets and foreign competition. Following a merger with Clarks and a short-lived resurgence in fortunes, the Kendal factory eventually closed in 2003.

Snuff, alongside other tobacco products, is still being made in Kendal and evidence can be seen in the town at Canal Head and in Lowther Street where you can see the figure of a Saracen or Turk on the wall smoking a pipe. The industry was far larger than it is now, and in the 1800s was particularly fashionable. One little-known fact is that miners would take snuff if they smoked to still get the nicotine hit even when down the pit.

DID YOU KNOW?
In the early 1600s, it was alleged the locally produced snuff would ward off the plague. This was probably because of the belief that miasma (bad air) was the reason for its spreading.

In a working town there is a thirst that needs to be quenched, but the reality is the water supply was usually unreliable and tainted, therefore people used to drink beer. They used to produce a 'small beer', so-called because it was low in alcohol and was even consumed by children. The town has had various breweries over the years and it is possible the Ring o' Bells was originally Zachary and John' built for the church wardens to brew their ale. On the 1770 map there is a brewery shown on Wildman Street, known as John Jackson Banks Old Brewery, which operated until 1884 when it became J. J. Banks & Son, but ceased to brew in 1903.

Highgate had a brewery licensed in 1758 and 100 years later a new brewery was built. This brewery was taken over by Vaux Breweries of Sunderland in the late 1940s but closed in 1968. Now the Old Brewery House forms part of the Brewery Arts complex. Beezon Brewery was in Sandes Avenue and this was taken over by Duttons of Blackburn in 1947 and closed in 1954.

One brewery just outside of Kendal called the Handsome Brewery is one of the many microbreweries currently springing up, and I can say I enjoyed their FKR Lager.

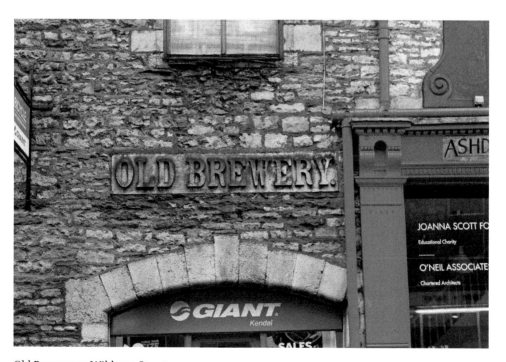

Old Brewery on Wildman Street.

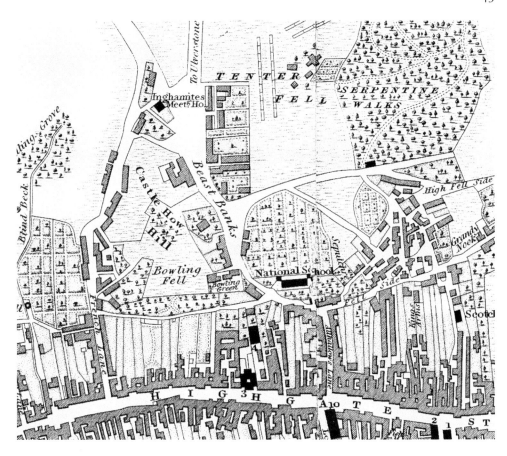

Above: 1832 map showing Highgate and a more open Beast Banks, with the bowling green on Castle Howe.

Right: Top of Beast Banks, looking towards Greenside.

Other industries located in and around Kendal included carpet making, hosiery, quarrying, iron foundries and financial services including banking and Insurance. These days the tourist and hospitality industry is the fastest-growing employer in a town on the edge of the Lake District.

5. The People of Kendal

Below are selected years showing the population of Kendal; the early ones are estimates based on various sources, and the others after 1801 are based on census years. As mentioned earlier in Chapter 3, the estimates for 1576–1695 hardly change due to disease, famine and war. The sudden increase in 1784 can be accounted for by the increased industrialisation and people coming from a rural life to live and work in the towns. A further boost can be seen in 1821 following the construction of the canal, and following the introduction of the railway the population continues to rise.

1576: 3,200
1695: 3,200
1784: 7,500
1801: 7,978
1821: 10,362
1841: 11,770
1861: 12,028
1881: 13,696
1911: 14,033
1951: 18,544
1971: 21,581
2001: 27,521
2011: 28,586
Current estimate: 29,000 plus

Every single one of these people from the numerous generations will have their own stories, and so below is just a few of the more noteworthy ones in the history of Kendal.

DID YOU KNOW?
There are ten dental practices in Kendal for a population of c. 28,000. York with a population of around 200,000 has the same number, but Lancaster with a population of about 138,000 has only seven practices – is it the Mint Cake?

Ephraim Chambers

Chambers was the author of the *Cyclopaedia of English Literature* and is buried in the north cloister of Westminster Abbey. There is a white marble monument on the wall with a Latin inscription, which when translated says:

> Common to many, known by few, who between light and shade neither learned nor simple, passed a life devoted to literature; But as a man, held nothing human foreign from his cause, his days and labours together discharged here wished to rest EPHRAIM CHAMBERS, F. R. S. He died May 15 1740.

He was born in 1680 at Milton, a small hamlet near Kendal, a son of a farmer and was apprenticed in London to a map-maker. After a few years he had the idea to produce a larger cyclopaedia than any that was available at the time. He published *A Universal Dictionary of Arts and Sciences* in 1728, followed by later editions. He died at Canonbury House in Islington.

Zachary Hubbersty and John Lodge Hubbersty

Close to the Bellingham chapel in Kendal Church is a memorial that drew my attention because of the association to my home town. The memorial reads:

> Sacred to the memory of Zachary Hubbersty of Great Winchester Street, London, Esquire, who died on the 23rd September 1797, in the 41st year of his age, leaving a disconsolate widow and six children. Few equalled and none excelled him in professional knowledge, and strict integrity; and of whom the learned and virtuous Lord Eldon in a letter of condolence to the deceased's brother observed, 'his loss is not more to be lamented by his family than by the profession, of which he was an ornament, and an honour.' Also of Phillis Sarah Hubbersty his second daughter who in the following years. lost her life by falling into the sea from the pier in Whitby harbour. This monument is erected by John Lodge Hubbersty, Esqre. Senior Fellow of Queen's College, Deputy High Steward of the University of Cambridge, and Recorder of Lancaster, who has never ceased to lament the loss of the best of brothers and friends.

Zachary and John were the sons of Zachary Senior (1726–1780) who was an attorney from Fallen Yew, Underbarrow. Zachary Senior was married to Phyllis Lodge of Barnard Castle in County Durham and had 6 children, one being Zachary, and another being, John Lodge Hubbersty.

In St Mary's Church in Barnard Castle there is a slab near the nave inscribed with:

> Here lieth interred Ann the Daughter of Zachary Hubbersty of Kirkby Kendal in the County of Westmoreland Gentleman by Phillis his Wife the fourth Daughter of John Lodge Gentleman who died the 26th Day of February 1757 aged 4 years.

Near this an another stone flag is inscribed:

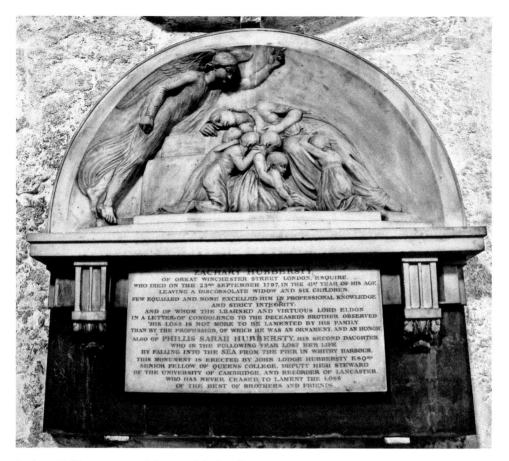

Zachary Hubbersty memorial in Kendal Church.

Phillis Lodge Wife of John Lodge Gent died 26th Nov. 1725 Aged 40. John Lodge died 18th Novr. 1743 Aged 61 John Lodge Junr. died 26th April 1743 Aged 26. William, Lodge eldest son of John and Phillis Lodge (lied 12th of Decr. 1766 Aged 34. Sarah Lodge eldest Daughter of John and Phillis Lodge died Decr. 1781 Aged 61.

In the Westmorland Church Notes of Kendal there is:

In memory of Zachary Hubbersty of Fallen Yew in Underbarrow, Attorney at Law, who died March 13, 1780 Aged 54 years. Also of Phillis Hubbersty daughter of John Lodge of Barnard Castle in the County of Durham, she died November 12, 1781 aged 61 years.

Zachary Junior made his will on 21 April 1792 and is described as being of Winchester Street, London. He left his 'real and personal property' to his wife Susanna, and appointed her sole executor. However, if she did not wish to act then he appointed John Lodge Hubbersty and John Matthews (his brother-in-law) as executors.

John Lodge Hubbersty, MA, MD, who seems to have been given the maiden name of his mother for his middle name, was a well-known character. He was a fellow of Queens College, Cambridge, from 1781 to 1838, though he lived at least part of the time in Lancaster where he was Recorder and a Free Burgess. He was described in the *Gazette* as: 'Fellow of Queens', M.A., Doctor of medicine, Barrister-at-Law, Recorder of Lancaster, a cotton-spinner, and a bankrupt.'

William Hudson

Hudson was born at the White Lion Inn in Kendal around 1730, and became a respected botanist and apothecary (druggist or chemist) who practiced in London. He was educated at Kendal grammar school and apprenticed to a London apothecary. From 1757–68 Hudson was resident sub-librarian of the British Museum and in 1761 he was elected a fellow of the Royal Society. The following year appeared the first edition of his *Flora Anglica*, a well-respected and acknowledged classification of botany in England. At the time of its publication he was practising as an apothecary in Panton Street, Haymarket, and from 1765–71 he was the Demonstrator and '*Praefectus Horti*' for the Chelsea Physic Garden. Founded in 1673 and originally known as the *Apothecaries' Garden*, the organisation had the purpose of training apprentices in the identification and use of medicinal plants.

In 1783 his house in Panton Street took fire and as a timid man he refused to open his doors, afraid the mob would plunder his house. Much of his collection of insects and plants were destroyed, and he narrowly escaped with his life. Retiring to Jermyn Street, he died from paralysis on 23 May 1793 and bequeathed the remains of his herbarium to the Apothecaries' Company. Hudson was buried in St James's Church in Westminster, London.

DID YOU KNOW?
The town's fire engines were kept at the Shambles and Coward's Yards.

Francis Howgill

A WOE AGAINST THE
Magistrates, Priests, and People
OF KENDAL
in the County of Westmorland,
Pronounced from the Lord by one of his PROPHETS.
Which may warn all the persecuting Cities and Towns in the North, and everywhere, to
Repent and fear the Lord, lest the Decree go forth against them.
Also the Stumbling-block removed from weak Minds, who are offended at the strange Signs
and wonders acted by the Servants of the Lord,
scornfully called QUAKERS In the Northern
parts of this Nation.

LONDON, Printed in the Year, 1654

Francis Howgill (1618–69) was a Quaker activist who had a major role in the growth and development of the movement. Born in Todthorne, near Grayrigg, Westmorland, it is believed he was descended from a yeoman. His early life is unclear and some sources say he received a university education and experimented with independent or Baptist forms of worship. He is said to have been a minister in Colton, Lancashire, and around 1652 he was the minister of a congregation at or near Sedbergh. It was during this period he and another minister were converted to Quakerism by George Fox. Almost immediately Howgill travelled as a Quaker preacher and is supposed to have done so at Firbank Chapel, Westmoreland.

He showed support at James Naylor's trial (a Quaker activist) in Appleby for blasphemy but only enraged the judges by refusing to remove his hat. His hat was burned and he was imprisoned for five months. Naylor himself was to be no stranger to controversy: following another period of imprisonment in Exeter, Naylor was accused of impersonating Christ. Under the 1650 Blasphemy Act he was declared guilty in December 1656 and a ferocious debate ensued regarding his punishment, with some MPs demanding that he should be stoned to death in accordance with the Old Testament penalty for blasphemy. Oliver Cromwell's call for leniency was not followed as Naylor was sentenced to be whipped through the streets, exposed in the pillory (stocks), to have his tongue pierced with a red-hot iron and to have the letter 'B' for blasphemer branded on his forehead. He was then returned to Bristol where he was whipped again and was finally taken back to London and committed to solitary confinement in Bridewell for two years. This man certainly abused the term unlucky, for while travelling home to his family back in Yorkshire, following his release from incarceration, he was robbed and left for dead. He died a couple of days later aged forty-two.

DID YOU KNOW?
It was common for those who died on the gallows to be handed to surgeons for dissection. Supposedly, one of the last victims treated this way from Gallows Hill, Appleby, was George Mackereth of Kendal, who was hanged in 1748 for the murder of his sweetheart.

Following Appleby, Howgill travelled around the country preaching to those who would listen. It is likely he was with Naylor in 1656 as Bristol magistrates ordered him to leave the city, and failing to do so the Quakers were attacked by the inhabitants. There was a warrant issued for his arrest, but he somehow managed to avoid capture, possibly because of his 'general amiability'.

Howgill recommended the Quaker practice of going 'naked as a sign' in *A Woe against the Magistrates, Priests, and People of Kendall* (1654), believed to be a symbol of your vulnerability in the sight of God. He continued to travel and preach and is recorded as being imprisoned in London in 1661. He became increasingly distrustful and vocal after the Restoration of the Monarchy, claiming in his writings *One Warning More* (1660) that the nation had 'Chosen

Madness for thy Crown'. But with his strength failing by 1663, at Kendal he was summoned by the high constable for preaching and refused to take the oath of allegiance. He declined to give a bond for good behaviour and was sent to prison until the assizes. In August 1664, he was convicted and sentenced to life imprisonment. After becoming sick while imprisoned at Appleby Gaol, he died in 1669 and was buried on 20 February.

Howgill was a prolific writer and during the seventeenth and eighteenth centuries his works were much valued by the Quakers.

William Strickland, Bishop of Carlisle

William Strickland was born into the Strickland family of Sizergh in 1336 and became the Bishop of Carlisle, having a major influence on the area. It is believed he served as the rector of Ousby and parson of Rothbury before becoming the chaplain to Thomas Appleby, Bishop of Carlisle. He was appointed bishop himself in 1396 by Pope Boniface IX, but was not at first accepted by the King. He was not recognised until 1400, after he had been elected by the chapter and agreement reached with the King, Strickland was then consecrated by the archbishop of York at Cawood, in Yorkshire, on 24 August.

DID YOU KNOW?
Joan Strickland was married to Robert de Wessington, an early ancestor of the first president of the United States – George Washington.

Strickland was one of the commissioners sent to negotiate peace with Scotland in 1401 and in 1402 was engaged to arrest any persons suspected of claiming that Richard II was still alive (it is believed he starved to death at Pontefract Castle). In 1404 he was granted

Sizergh Castle.

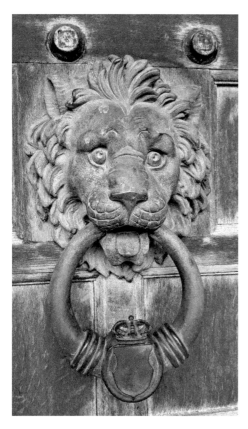

Sizergh Castle door knocker.

the office of constable of Rose Castle and Strickland was one of the witnesses of the act declaring the succession to the Crown in 1406.

Strickland died in 1419 at Rose Castle and was buried in the north aisle of Carlisle Cathedral as he requested in his will.

Barnaby Potter

Barnaby Potter was born around 1577, the son of Thomas Potter, mercer and alderman of Kendal. After schooling at Kendal he was further educated in Queen's College, Oxford, where he became scholar, fellow and eventually the dignity of provost. He maintained his position for ten years and was one of James I's chaplains. When Charles I came to the Crown in 1625, Potter was made Bishop of Carlisle and it is said 'he was of a weak constitution, melancholy, lean, and a hard student.' He died in London in January 1641, and was the last bishop who died as a Member of Parliament. After the Civil Wars the rest of the bishops were excluded from the House of Peers. He published several works but is best remembered for two volumes of lectures and a book of sermons.

The Parr Family

Originally known as the DeParres, the Parr family were dominant in the Kendal area and attained the title Barons of Kendal. They had considerable influence during the Wars

of the Roses, with William Parr being a skilled negotiator for the Crown. John Parr was Sheriff of Westmorland and between them they controlled huge swathes of Cumberland and Westmorland. At the time of holding the barony of Kendal they are believed to have made changes to the castle to improve and modernise the living space.

The Parr families' fortunes ebbed and flowed as the Yorkist cause swung to and fro. William did not support the coronation of Richard III and moved back to Kendal before dying later in 1483. He is buried in the Parr chapel of Kendal Church, which is much understated and shows only a few coats of arms.

William's granddaughter, Katherine Parr, is the most famous member of the family as the wife of Henry VIII, and though the local legends say she was born in the castle it is more likely she was born at the Parr's London residence. Katherine was born around 1512 and it is likely the castle was abandoned by this time. Katherine is supposed to have lived at Sizergh Castle for a few years before she was married to Henry VIII but it is unsure if she ever entered Kendal.

In 1553, following the death of Edward VI, Katherine's brother, William, Marquess of Northampton, backed the succession of Lady Jane Grey over that of Mary I. Known as the 'queen of nine days', Lady Jane was executed nine days after her claim to the throne, and William Parr was imprisoned and his titles removed until his release by Elizabeth I when she ascended the throne in 1558.

Dickie Doodle

Kendal has a long-standing legend based on a story about a king's messenger that led to the setting up of a mock mayor and a fictitious area of Kendal.

The story tells of a young messenger sent by Richard I (the Lionheart) with the town's first charter, but upon arrival he proceeded to the local hostelry, became drunk, and upset the locals. He was then chased through the town to the River Kent, where he tried to escape by wading to the other side. This area around Far Cross Bank was inhabited by the poor, and Dickie was welcomed by the people who cheered his escape from the townsfolk on the other side of the river. He then set up his own county of Doodleshire and perhaps still full of drink, put himself in charge.

Continuing the legend in the eighteenth century, each year in October on 'Dickie Doodleday' the residents of 'Doodleshire' set up a mock town corporation and appointed a town mayor. There was a formal ceremony followed by a procession, sports and activities to celebrate.

In 1829 James Wiggin, a local weaver, was elected as Mayor of Doodleshire. He rode the boundaries of Doodleshire on a tall horse, dressed up in a red-brown wig and held his staff of office, topped with a blue ribbon. Apparently on his way round he was imbibed with ale and was so drunk he had to sleep it off. Some people took advantage of this and blackened his face with soot, but when he found out he was so angry he refused to carry on with the role. Later on he joined in the fun, 'swearing to be a good Mayor and discharge his duties well'. The next day he was formally invested as mayor for a year and the blacking of the new mayor's face became a tradition.

The custom continued until 1837 and some sports were maintained for some years after but eventually stopped. There were attempts to resurrect the ceremony in 1974 and

the mayor of Doodleshire revived with a sports day in 2007, but it failed to capture the imagination and was not continued after a couple of years.

Joseph Mallord William Turner

The Lake District had been visited in the past by writers such as Daniel Defoe, but it was 1778 when Father Thomas West published *A Guide to the Lakes*, which is considered to be the first real tourist guide. In his guide he recommends the finest locations for visitors to stand and appreciate the landscape of the area. In 1820 William Wordsworth published his own guide book *A Guide through the District of the Lakes in the North of England*. Wordsworth's work became very popular and combined with the writings of poets such as Southey and Coleridge, the Lake District was being promoted for its beauty and splendour. Political upheaval following the French Revolution and the Napoleonic Wars in Europe also meant that wealthy tourists, who would have usually visited the great cities of Europe, were looking for different travel options in this country.

There was also a resurgence of landscape artists who looked to visit the Lake District and the magnificent scenery available to them. Joseph Mallord William Turner (1775–1851), one of our finest landscape artists, visited Kendal on several occasions and actually sketched views of Kendal from The Helm. Some of his sketchbooks, housed in the Tate, show Kendal from this vantage point with Nether Bridge, the church, Kendal Fell and the castle shown. He rode miles on horseback exploring market towns like Barnard Castle, Penrith and Kendal, staying in small inns and making sketches in his notebooks to be painted at a later date.

The Abbot Hall Art Gallery in Kendal contains a couple of Turner works, a magnificent early watercolour *The Passage of Mount St Gothard*, and an 1821 watercolour called *Windermere*.

John Ruskin

The Victorian art critic and social commentator John Ruskin (1819–1900) lived in the Lake District at the end of his life, and Abbot Hall possesses one of the most comprehensive collections of his drawings and watercolours in the country. Only one drawing and one watercolour relate to the Lake District, with the remainder covering a wide range of subjects including natural history, mountains and topography in Germany, Switzerland, Italy and France as well as Britain.

George Romney

George Romney was one of the most celebrated portrait painters of his time and though he was not born in Kendal, the town played a huge part in his life. He was born in Dalton-in-Furness in 1734, where he appears to have been a poor student and was apprenticed to his father's cabinet-making business, where he showed artistic skill. He arrived in Kendal to work with respected portrait painter Christopher Steele in 1755 before breaking with him in 1757 to set up his own studio in Kendal.

In 1756 he married Mary Abbot, the daughter of his Kendal landlady, and by 1760 he was the father of two children. Romney had built up a favourable reputation with portraits of the local gentry but his future was in London, and by 1762 he set off for

London by himself where he stayed until 1799, with only a few visits back to Kendal. Effectively separated from his family, he still remained contact and financially supported them.

Romney began to achieve success in London in particular his portraits of 'society women' and was in high demand. His growing reputation and his reasonable fees did not please Sir Joshua Reynolds, President of the Royal Academy. He never submitted paintings to the Royal Academy and this clearly affected his career and earning potential later. He spent most of his time in London apart from a couple of years travelling, studying and sketching in Italy.

After meeting Emma Hart in 1782 he became obsessed with her as a subject for his paintings. She was clearly a very attractive woman, who later became Lady Hamilton and the infamous mistress of Horatio Nelson.

For whatever reason, Romney returned to Kendal and his wife in 1799 and lived in a house near Nether Bridge. He died on 15 November 1802 and was buried in Dalton.

Romney was very prolific and left a legacy of 2,000 paintings and around 5,000 drawings, with many fine examples on display at the Abbot Hall Art Gallery.

Plaque on the Town Hall to commemorate George Romney.

Trooper William Pearson

In the Parkside Cemetery there is a headstone with an ornate cross, which has the following inscription:

IN LOVING REMEMBRANCE OF
WILLIAM PEARSON
LATE OF THE 4TH QUEEN'S OWN LIGHT DRAGOONS
AND ONE OF THE SIX HUNDRED IN THE
CHARGE OF THE LIGHT BRIGADE AT BALACLAVA
OCT 25TH 1854.

BORN OCT 2ND 1826, DIED JULY 31ST 1909

ALSO OF ELIZABETH, WIDOW OF THE ABOVE

BORN MARCH 3RD 1836, DIED JAN 27TH 1925

William Pearson was a combatant of the Crimea War who took part in the Charge of the Light Brigade. The Crimean War (1853–56) was fought by an alliance of France, Great Britain and the Ottoman Empire against Russian imperial expansion. William Pearson was born in Penrith and became a leather dresser before running away to join the 4th Light Dragoons in 1848.

The Charge of the Light Brigade is infamous because it involved lightly armed cavalrymen with lances and sabres bounding headlong into a valley brimming with Russian cannon. It was Lord Tennyson who suggested in his well-known poem that somebody blundered on that day: 'Into the valley of Death rode the six hundred'; 'Cannon to the right of them, cannon to the left of them, cannon in front of them'.

Grave of Trooper William Pearson, Kendal Parkside Cemetery. (Photo by kind permission of A Bit About Britain www.bitaboutbritain.com)

Evidence suggests an unclear or misinterpreted order resulted in the Earl of Cardigan leading a charge of 673 soldiers into a volley of fire, where 270 soldiers were killed or wounded and they also lost approximately 375 horses in the process.

During the Charge, William Pearson's horse fell over another that had already tumbled and he had to mount a riderless horse of the 8th Hussars. He had an epaulette shot from his shoulder and was wounded on his forehead during the battle. Lucky to survive the battle, he later suffered frostbite during the harsh Crimean winter and spent Christmas Eve 1854 having four toes amputated. He recuperated in the hospital in Scutari – the hospital made famous by Florence Nightingale – and was later invalided home.

He was presented before Queen Victoria in 1855, received the Crimea Medal, Turkish Medal and a Good Conduct badge before being discharged as unfit for further military service. He returned to Penrith with a wife he met in Dover and became the Inspecting Officer's Orderly to the Dalemain Troop, Cumberland and Westmorland Imperial Yeomanry. In 1880 he moved to Underbarrow, near Kendal, where he set up a fellmongering (a dealer in hides or skins, particularly sheepskins) and tanning business. Retiring in 1906, he died in July 1909 at the age of eighty-two and was buried with military honours in Parkside Cemetery.

Duke of Kendal

There has only been one Duke of Kendal, this was Charles Stewart (4 July 1666–22 May 1667) who was given the title by his father James II, but he died when he was only young. This was the third child of James and his first wife Anne Hyde. Charles is buried in Westminster Abbey.

Duchess of Kendal

The only Duchess of Kendal was a German lady who came to England with George I and was honoured with the title. Her name was Ehrengard Melusine von der Schulenburg, Duchess of Kendal, Duchess of Munster (25 December 1667–10 May 1743) and long-time mistress to George I.

Kendal Trinity Church.

King James I

In 1617 James I lodged in Kendal as he returned to England from Scotland. He spent two nights in Carlisle and two more in Kendal. He stayed in Stricklandgate at Brownsword House, later known as the Pack Horse Inn and the site of the present Kendal Library. While in Kendal he knighted Sir Henry Mildmay (who later ironically was one of the regicides), Sir George Spencer and Sir Francis Knightley (cup bearer). Upon the Restoration of the Monarchy in 1660, Mildmay was stripped of his lands, offices and title for having served as a judge during the trial of Charles I. He was sentenced to a traitor's death but was commuted to life imprisonment in the Tower, and in 1664 he was to be transferred to Tangiers. Apparently he died before the transfer was carried out in 1668.

Thomas Longmire

A regular visitor to Kendal was Thomas Longmire, who was born in 1823 at Stybarrow Cottage, a little more than half a mile from Windermere. He was born to a family of bobbin makers but one of his favourite pastimes was wrestling, and in 1840, aged only seventeen, he won his first wrestling belt at Threlkeld, near Keswick. He continued to compete well and in 1842 he became the All Weights champion at the Ferry Sports at Windermere.

It was at this 1842 meeting that a contest was arranged between him and a wrestler called Nelson, to take place in Kendal Castle courtyard in August. He won the bout, continued to do well locally over the next few years, and began to travel further afield including to London.

In 1848, he married a local girl called Sarah Birkett from Troutbeck Bridge and produced eleven sons and one daughter. He was a publican at the New Hall Inn at Bowness, and later the Commercial Inn, Bowness, but rarely competed. It was not until 1851 in Newcastle that he won first prize against some of the best wrestlers in the north. In 1857, Charles Dickens attended the Ferry Sports at Windermere to see Longmire win his 175th wrestling belt and took note of local customs, dialect and sports of the area. It is said Dickens visited Longmire and was eager to learn more about the Cumberland and Westmorland style of wrestling. The story goes that Longmire proceeded to demonstrate some holds and ended up by throwing Dickens to the ground. Dickens later wrote:

> Good wrestlers rarely hurt one another. This quiet looking giant by our side, who has been champion often and often – and will be again one day, although he is nearly 40 and more than 12 years past the wrestler's prime – has never, in his 20 years' experience, once been hurt. He won his first man's belt when a lad of 16 years old, and in his house across the lake yonder – a clean, neat little inn, set in a wilderness of flowers – has no less than one hundred and seventy four of these wrestling zones; of all colours they are, and of all descriptions, from the broad, plain Manchester-looking belt won at that matter of fact and unornamental town, to the splendid award of Newcastle, embossed with the silver towers.

In 1858 he defeated Hawksworth, another great wrestler, at Kendal, and won a handsome prize but two years later, at the age of thirty-six, he retired. He became an umpire for the

Grasmere Sports Committee for thirty years until he died at the Sun Hotel, Troutbeck, on 11 February 1899. He is buried in Troutbeck Churchyard.

George Webster

One of the key figures in how Kendal looks today was George Webster (1797–1864) or, to be more precise, the Webster family, who came from Kendal. His father, Francis, and his brother, also Francis, are also credited with some designs.

George Webster came from a family of stonemasons, builders and architects, with his father being credited with the Assembly Rooms and Market Hall in Hawkshead as well the Wakefield Bank building in Stricklandgate in 1797. At the turn of the century he was working for Lord Lonsdale in Whitehaven and at Lowther Hall, the Lord's residence. It is assumed George apprenticed for his father's business and learnt his trade under him.

George was even appointed Mayor of Kendal in 1829–30, but his real legacy is still to be seen in the town. Just some of the buildings he is attributed with include St Thomas' Church on Stricklandgate, St George's on Castle Street, Kendal Town Hall, the Working Men's Institute, Friends Meeting House, Westmorland Bank, Sandaire House and the National School. There are many more in and around the locality, including buildings in Natland, Ulverston and Kirkby Lonsdale.

Between the years 1845 and 1872 the practice was continued by Miles Thompson, the Websters' former draughtsman, but George died in 1864 aged sixty-six.

The family retired to Eller How, a house in Lindale that was chosen for its remote position in the valley, and George tried to improve the estate by adding a number of follies. They are interred in the family mausoleum (designed by the family), which is located in the churchyard of St Paul's Church in Lindale.

Miller Bridge – designed and built by George Webster.

Sandaire Building – designed by George Webster.

John Cunliffe

John Arthur Cunliffe is an author of children's books who created the famous characters of Postman Pat as well as Rosie and Jim. He lived in Kendal for a number of years and the local area was the inspiration some of his stories. Greendale, the fictional village from *Postman Pat*, was based on the Longsleddale and the post office in Greendale was inspired by Beast Banks post office (now closed).

The series was commissioned for thirteen episodes by the BBC, with his scripts animated and directed by Ivor Wood. The first episode, 'Postman Pat's Finding Day', was broadcast on 16 September 1981. The show was a massive success with another series commissioned, along with spin-off shows and merchandise.

Cunliffe also created *Rosie and Jim*, another successful television series in the early '90s, which ran for fifty episodes, a number of which he turned into books.

Keith Stainton

Keith Monin Stainton (1921–2001) was born in Kendal, the son of a Kendal butcher and a Belgian refugee his father had met during the First World War. He attended Kendal School before working as an insurance clerk until the outbreak of the Second World War. In 1940, he volunteered for the Navy and was commissioned into the Royal Naval Volunteer Reserve. He served with distinction as the British Liasion Officer on submarines and with

the French resistance being awarded the *Légion d'honneur*, the *Croix de Guerre avec Palme* and a citation *à l'ordre de L'Armée* for his spy landings and actions in the Mediterranean.

He was a Conservative politician. Lead writer for the *Financial Times* (1949–52), an industrial consultant (1952-57), and joined Burton, Son & Sanders Ltd in 1957 as managing director. He was chairman of Scotia Investments Ltd in 1969–72 and the MP for Sudbury and Woodbridge in 1963–83. He was member of the House of Commons Select Committees on Expenditure and Science and Technology as well as a member of the Council of Europe and WEU in 1979–83. The constituency seat was abolished by boundary changes in 1983.

Alfred Wainwright

So much has been said about this man, so what more can be added here but as a famous resident of Kendal, he also cannot be overlooked. Born in Blackburn, he was and still is a much-loved author and fell walker who worked in Kendal at the Borough Treasurer's office, probably to be closer to his beloved Lake District. It has been said that he didn't get on with people, could be cantankerous and preferred to be out walking on his own, but there is no denying his legacy of work. His pictorial guides to the Lakes are still selling well and have a timeless, natural spirit in the way they are written. One of the yards (Yard 28) now bears his name.

David Starkey

David Starkey is a renowned historian, radio and television presenter who was born in Kendal, and attended Kendal Grammar School before studying at Cambridge. Quoted as saying 'I can be a bit harsh', he is often controversial, outspoken and some would say rude. His frank views may not please everyone but sometimes in history there is no place for beating about the bush and a direct approach may on occasion be desirable.

His works include *The Reign of Henry VIII*, *The Six Wives*, *Monarchy*, *Crown and Country* and *Magna Carta* to name but a few. He has also presented several television programmes covering the Tudors and other monarchs. He was awarded the CBE in 2007.

6. Buildings

Kendal has at least 186 listed buildings, and though this is not a complete list, here is a selection of structures or homes that have a significant part to play in the history of Kendal.

Sizergh Castle

Sizergh Castle sits around 2 miles to the south of Kendal and has been the home of the Strickland family for over 700 years. The land around Sizergh has been occupied since as early as the ninth century by Vikings who settled and farmed the land. In the 1170s Sizergh was included as part of a larger tract of land granted to Gervase Deincourt by Henry II. The main branch of the Deincourt family settled in Blankney in Lincolnshire but in 1239 when Gervase's great-grandson died, the estate was taken over by Elizabeth, his great-granddaughter who was the heiress to the vast estate. By the laws of the time the ownership passed to her husband, Sir William Strickland.

The Strickland name can be traced back to a family called de Castlecarrock, who are most likely descended from a Norman family called the Vaux's or de Vallibus. It is believed a Walter de Castlecarrock moved south to an area called Great Strickland in the late twelfth century and changed his name to de Strikeland. Earlier we saw the Domesday Book refer to an area called 'Stercaland' and this was obviously adopted as a moniker. It was Walter's grandson who became Sir William Strickland, the husband of Elizabeth Deincourt.

The castle's earliest remains are of a fortified manor house or pele tower dating from around 1340. The four-storey tower was probably built after Sir Walter was granted a licence to crenelate in 1332 and to enclose his lands to create a park. This was completely altered in the late 1550s and early 1560s by Walter Strickland, who modernised the solar tower, built a new hall, rebuilt the service block and added two long wings. Alterations were also made throughout the eighteenth century, again in the nineteenth century and again in the early twentieth century. This is a common practice regarding the remaining stately homes of the region such as Hutton, Levens and Muncaster. After works in 1891 the panelling and overmantel of the Inlaid Chamber was removed to the Victoria and Albert Museum.

The Strickland family have a long history of alliance with the Parr family, and there is a chapel dedicated to the Strickland family in Kendal parish church. Katherine Parr lived at Sizergh Castle for a number of years before she was married to Henry VIII and she allegedly sent him a coat of Kendal cloth as a gift. Her room at the castle still displays the huge counterpane and toilet cover that Katherine embroidered. Her quarters are situated in the oldest portion of the castle, which was called the Deincourt Tower after the old family name.

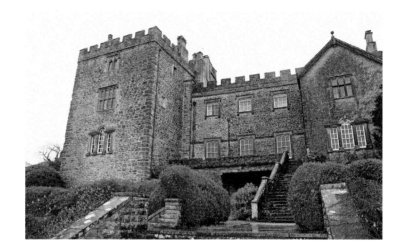

Sizergh Castle.

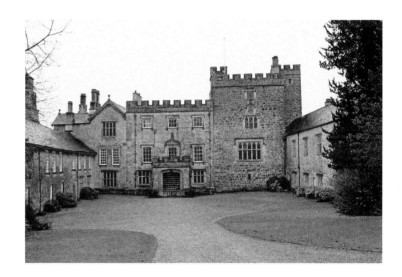

Sizergh Castle.

Brigsteer Road
with Kendal sign
and racecourse
in background.

Kendal Racecourse

To the west of the town, off Brigsteer Road and below Scout Scar, are the remnants of Kendal Racecourse. The cost for building the racecourse was raised by subscription from wealthy locals and situated on land that was called Fisher's Plain. The first race meeting was held on 7 August 1821, followed every year by a three-day meeting in June. The feature race was the Kendal Gold Cup, with a substantial first prize of £50; the first ever winner was called Miss Syntax and owned by Lord Queensberry.

Apparently there was no meeting in 1823 because of the Reform Bill crisis – when outbreaks of violence in the country led to crowd gatherings being discouraged. The final meeting was held in 1834, although further meetings were held from 1879–82 and offered National Hunt cards containing both 'flat' and 'hurdle' races over 2 miles. It was used for different events like the Kendal Steeple Chase, and some racing was held during the First World War, but it was generally abandoned thereafter. Other uses have included practice ground for the Kendal/Westmorland Yeomanry and even the establishment of a small golf course for a short time.

Still clearly visible as a raised flat platform, the site can be accessed from a public footpath. Other remnants appear to be entrance gates, raised banks for racegoers to stand and rubble from old buildings.

Elba Monument

To the north-west of the town and on raised land close to the A591, is a monument erected in 1814 by James Bateman of Tolson Hall. Built as an obelisk of squared and coursed

The racecourse and public access.

limestone and known as the Elba Monument, there is a certain irony to its construction. A plaque was supposed to adorn the monument when it was built, saying 'In honour of William Pitt the Pilot that weathered the storm'. This was to commemorate the capture of Napoleon and his exile to the Isle of Elba, but he escaped within the year before being finally defeated at Waterloo in 1815.

It was not until 1914 that a tablet was eventually fixed to the monument by the gift of Charles Cropper of Ellergreen. He used the original words of Bateman but with a short explanation and date below. The monument is also sometimes known as the Pitt Obelisk.

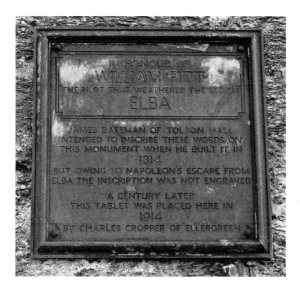

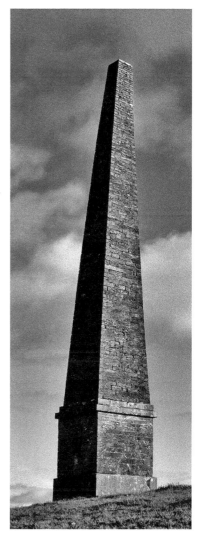

Above: The Elba Monument inscription.
Right: The Elba Monument.

Old Spittal

To the north-east of the town, on the A685 road, is a Farmhouse called Spital, which was the site of a leper hospital called St Leonard's. The hospital is first mentioned in the thirteenth-century borough charter and is described in the inquisition after the death of William de Ros in 1310 as supporting a master, two chaplains and four lepers. Like many towns – and due to the fear associated with the disease – the hospital was built on the very western edge of the town. Seven field names are mentioned in a rental of land belonging to the 'Spittal of seynt Leaonardes' in 1550 and reappear on the 1753 Spittle Estate Plan. This confirms the endowment of land from which the hospital supported itself.

In 1544 the building was relinquished by the chaplain and finally abandoned in 1551. It is possible the site had been in use since 1250 and could have been demolished in 1692 by Richard Bailiff, who used the stone to build Tearnside Hall near Kirkby Lonsdale. Nothing of the hospital remains above ground, but the Spital Farm probably incorporates fragments of the medieval hospital in its back wall.

No. 7 Stramongate, Bellingham House

House No. 7 on Stramongate was built in 1546 according to the coat of arms on the building. It is said to have been the town house of the Bellingham family from Burneshead. They had seats at both Burneside and Levens Hall but as Barons of Kendal kept this house on Stramongate for expediency. As mentioned previously, the Bellingham family also have a chapel in the Kendal Trinity Church.

The building has two storeys with attic space, while the front elevation is adorned with the Bellingham coat of arms at high level, and the yard behind contains an old water pump. Inside there are two old fireplaces that possibly date to the late seventeenth century with ornately carved woodwork, including shields bearing three chevrons, and there is also a cupboard with a panelled door bearing the inscription '*JACOBVS GALLE II REX C.B*'. There are many other references to the Bellingham family inside, and various period features.

Bellingham House.

Coat of arms on Bellingham House.

Sleddall Hall.

The building was restored in 1863 for John Broadbent, and it is said it was he who placed panel showing Bellingham coat of arms and the date 1546 in the dormer window gable. As with many old buildings there are various tales attached; one local story maintains that at one time the house was occupied by an Agnes Harker, who was Captain Cook's sister. Whatever the truth, the house is probably the oldest building in Kendal still used as shop premises, and was further restored in the 1980s to its present condition.

Sleddall Hall

It is believed the hall was built around 1600 when Wildman Street was widened and major building activity was undertaken. The basis for this date is from when the interior was modernised and a piece of plaster decoration was discovered in a passage inscribed with '1600'. Built on a plot of land originally called the Croft, it is said to have later been

converted to an inn, which had various names over the years including the Pack Horse Inn, the Weavers Arms and the Farmers Arms.

The hall is named after Thomas Sleddall, who was the first to bear the title of Mayor of Kendal. He was appointed in 1636 as the senior alderman. Though little is known about the hall, two priest holes were found in the walls. These were spaces that travelling Catholic priests would have hidden; if found, it would have led to torture or death. Such hiding holes were common in larger houses. One was found in the right-hand gable-end wall and another in the thickness of the chimney.

Royal Observer Corps (ROC) Monitoring Post

Some of the secret parts of Kendal are not that far back in the town's history and on Aikrigg, a small hill to the south of Kendal Castle, is a ROC monitoring post. Most of the facility is underground and was designed to detect radioactive fallout and communicate with other posts. Posts were grouped together to form a cluster of between two and five posts. Each post was uniquely numbered with one post in the cluster selected as the master post. ROC Post Kendal, which was built in 1965, was only linked to one other at Dent, but was closed in 1991 following the end of the Cold War.

Kendal Library

According to Nicholson the Kendal Library was established in 1794, and in 1797 the 'Economical Library' was 'principally for the use and instruction of the working classes'. In 1825 an arrangement was made between the Mechanics' Institute and the Economical Library, and a library was established with two newsrooms, a subscription library, a book club and a natural history society, with a splendid museum containing a collection of antiquities and natural curiosities.

Another building in the Market Place was used as a library before the Carnegie Library was built in 1909. The old façade of the Market Place Library was actually moved onto

Carnegie Library.

Working Mens' Institute in Market Place.

Sandes Avenue and is now a shop front. The purpose-built town library, the Carnegie Library, opened on 20 March 1909. It was designed by Kendal architect T. F. Pennington and financed by Andrew Carnegie, a Scottish-American philanthropic millionaire, who set up a trust fund worldwide for the 'Improvement of the well-being of the masses of the people of Great Britain and Ireland'. This included the building of some 3,000 public libraries, 380 of which were in Britain. The trust fund still exists and continues to fulfil the role he intended.

Castle Dairy

The Castle Dairy is located in Wildman Street, not far off the end of Starmongate Bridge and north north-west of Kendal Castle. In all likelihood it is the oldest building in the town after the castle and the parish church. It is possible the building dates back to the fourteenth century and was perhaps part of a farm complex. Whether or not the building was associated with the castle is up for debate but we do know it was owned by Anthony Garnett around 1560, and that he was responsible for a number of alterations and extensions to the house. The Garnett/Braithwaite family seem to have occupied or owned the house over the centuries right up to Brigadier-General William Garnett Braithwaite, who was involved in the Boer War and the First World War until taken over by the Kendal Borough in 1923. Some of the symbolism inside relates to the Parr, Fitzhugh and Strickland families – to name but a few – to confuse the issue somewhat.

At the time of writing the building was closed and undergoing renovation after being used as a restaurant. When reopened, this magnificent medieval building will be well worth a visit, being perhaps the most intact building of its age in the town.

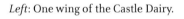

Above: Castle Dairy undergoing restoration in 2017.

Left: One wing of the Castle Dairy.

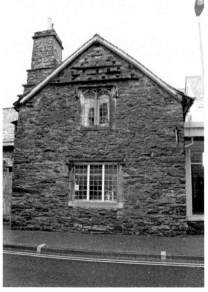

Sandes Hospital

This building in Highgate is essentially a gatehouse with almshouses behind, which were built by Thomas Sandes, a cloth merchant and one-time mayor of Kendal (1647–48). He founded a school and eight almshouses for poor widows, with the gatehouse as the master's house and single-story wings for the school, along with a library in the chamber over the archway. The actual build date is disputed but the plaque on the front of the

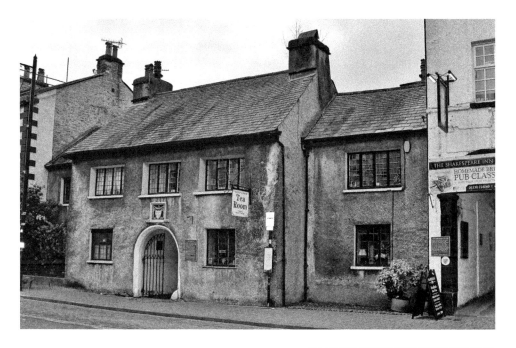

Above: Sandes Hospital.

Right: Almsbox in the archway of Sandes Hospital.

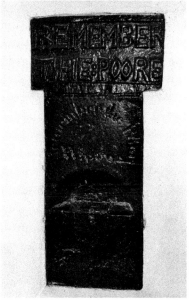

building states '1659'. Within the entrance arch is an old iron collecting box, or almsbox, with an iron lid, surmounted by an inscription 'REMEMBER THE POORE'.

The rows of cottages in the yard are arranged in pairs, with each pair entered by plank door in a shallow, gabled, porch. These cottages were rebuilt in 1852 by the architect Miles Thompson, a draughtsman of George Webster. In 1886 the school became part of Kendal Grammar School and merged later in 1980 with Kirkbie Kendal School, whose trustees still own the property.

A List of the Hotels, Inns and Taverns (Including Landlords) From an 1829 *Gazetteer*

Angel, George Bateman, Highgate.
Bird in Hand, Thomas Sisson, Kirkland.
Bishop Blaize, Agnes Bellingham, Highgate.
Black Bull's Head, Anthony Barrow, Kirkland.
Black Swan, John Taylor, Hallow lane.
Cock & Dolphin, Richard Spencer, Kirkland.
Commercial Hotel, James Webster, Highgate.
Crown, Arthur Cook, Strlcklandgate.
Dog & Duck, Elizabeth Dixon, Finkle Street.
Dolphin, John Bateman, Highgate.
Duke Charles, Thomas Braithwaite, Stramongate.
Duke of Cumberland, Thomas Garside, Far Cross Bank.
Dun Horse, George Clarke, Stramongate.
Elephant, Elizabeth Speight, Stricklandgate.
Fleece, John Hodgson, Highgate.
Foot Ball, Margaret Brocklebank, Market Place.
Fox & Goose, Henry Hoggarth, Highgate.
George & Dragon. Jas. Hanson, Market place.
Globe, Elizabeth Huddlestone, Market Place.
Golden Ball, Richard Lough, Hallow Lane.
Horse & Rainbow, James Barker, Highgate.
King's Arms Inn, John Jackson, Strlcklandgate.
Lowther's Arms, William Bailiff, Wildman Street.
Masons' Arms. Thomas Derome, Stramongate.
Nag's Head, James Thompson, Stramongate.
New Inn, Thomas Lewthwaite, Highgate.
Pack Horse, Mary Smallwood, Stricklandgate.
Pump, Jane Park, Stricklandgate.
Queen Catharine, Agnes Tate, Highgate.
Red Lion, Robert Skelton, Market Place.
Ring-of-Bells, William Braithwaite, Kirkland.
Rose & Crown, Stephen Archer, Stricklandgate.
Sawyer's Arms, Thomas Wells, Stricklandgate.
Seven Stars, Miles Colman, Stricklandgate.
Ship, Elizabeth Noble, Stricklandgate.

Slip Inn, John Askew, Market Place.
Unicorn, William Chipchase, Highgate.
Union Tavern, John Walker, Stricklandgate.
Weaver's Arms, William Bell, Wildman Street.
Wheat Sheaf, Ann Scott, Kirkland.
White Hart, Jane Brooks, Highgate.
White Horse, Joseph Goulden, Strickandgate.
White Lion, William Stainton, Stricklandgate.
Wool Pack, William Hartley, Stricklandgate.

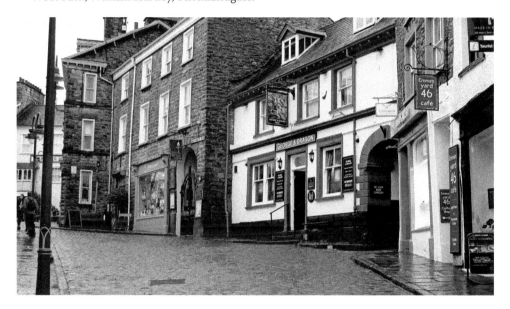

Above: George & Dragon.

Right: All Hallows Lane with Wetherspoons now
located in what was the public washhouse and baths.

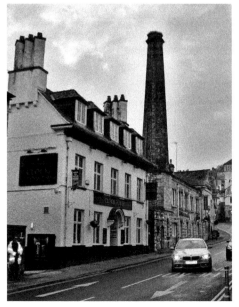

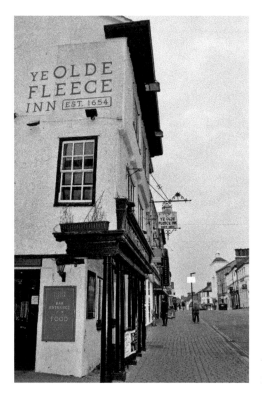

Ye Olde Fleece Inn claims to be the oldest in Kendal.

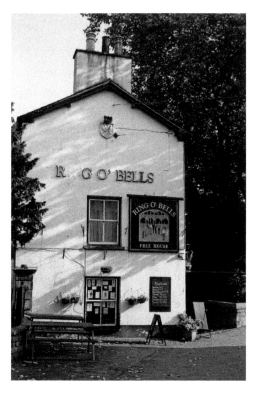

Ring O' Bells could be an older building but was not used as a public house until the mid-eighteenth century.

7. The Streets and Hidden Places

No Modern Town

The 1829 *Gazetteer* describes Kendal as 'no modern town' and explains 'proved by that old pile of buildings which was removed in 1803 from the middle of Highgate, and which from the time of its erection, about the year 1500, was called Newbiggin, signifying new building'. The actual layout of the town changed little from its medieval roots until 1782, when Lowther Street was built; two years later Stramongate Bridge was widened. The Mill Bridge, now known as Miller Bridge, had stood since 1668 and was rebuilt in 1818 when Kent Lane, now Kent Road, was widened.

The completion of the canal to Lancaster in 1819 stimulated a building spree on the eastern side of the river and 'extend the limits of the town'. There was an expansion of building in Wildman Street in 1819 and in the following year Caroline Street, Union Street, Cross Street and Strickland Place were formed by the Union Building Society.

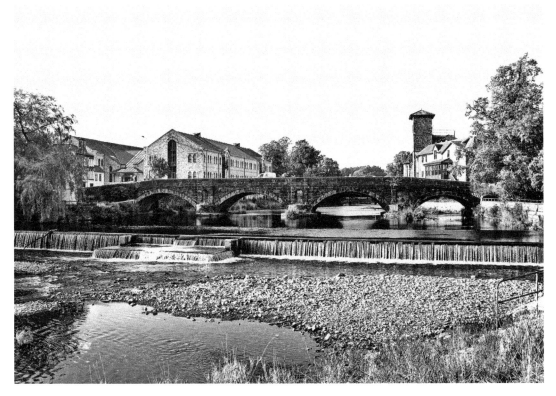

Stramongate Bridge.

Highgate sign.

The year 1822 seems to have been an important one for the improvement of the principal entrances to the town, which were widened at Nether Bridge, Stricklandgate and Wildman Street. The obstruction at Blind Beck Bridge was removed. This activity was followed by the construction of 'elegant houses' at Kent Terrace, Castle Row, now Castle Crescent, and the buildings forming Castle Street and Anne Street.

The next significant change to the balance of the town occurred between 1845 and 1847 with the arrival of the railways. Kendal station actually opened on 28 September 1846 at Long Pool before the line to Windermere was opened in 1847. This railway helped to stimulate further building works to this area and Far Cross Banks.

Highgate is simply named from being the highest street or gate in the town. This street was originally called Sowtergate (the southern street) in records from 1575.

Stricklandgate comes from the ancient family of Strickland, or is related to the nearby village recorded as Stircaland in the Domesday Book.

Finkle Street is derived from the Scandinavian 'vinkel', which signifies an elbow, corner or a horn in Old Norse (which would be obviously curved). The name is a common one in many towns like Carlisle, Bishop Auckland, Stockton-On-Tees and Newcastle-upon-Tyne. It follows that most Finkle Streets will have a sharp corner somewhere along their length, or if the streets have been widened or straightened, the name has survived.

DID YOU KNOW?
There was an ancient well in Finkle Street – a draw-well, with a rope and bucket. In 1594 two men were appointed to ensure the well was maintained and in good order.

Looking down towards Stramongate from Market Place.

Stramongate, was previously spelt 'Stramondgate', and is said to be called after a person named Straman. Speed's map of 1611 refers to it as 'Stramans Gate' and just as likely is that the area was known to flood and is derived from stream mound (according to Nicholson).

All Hallows' Lane is named from the chapel that stood at its head, now Middle Lane, and converted to flats. The chapel was dedicated to All Hallows, or All Saints, and in old English 'holy' or 'sanctified'.

Captain French Lane is possibly named after a gentleman called French who lived on or built on this lane sometime after Speed's 1611 map was published, where it is called Rotten Rowe. The only mention of Captain French found is that he was a churchwarden at the parish church in 1660 and it was he who built most of the houses on the lane.

Kirkland, as mentioned previously, is named from being near to or on the land of the church. It was a distinct township divided from Kendal by Blind Beck.

Lowther Street, or New Street, was not built until the 1780s and is named after the most prominent family of the county. The Lowthers, known as the Earls of Lonsdale, are also famous for the boxing belt still awarded to British boxers today.

Anchorite Place (formerly Work House Lane) is worth a mention and a little explanation. Speed's map of 1611 shows the 'Ankeriche Well' as a building and a walled enclosure located in the fields to the west of Kirkbarrow. The spring runs from the well into Kirkland, down the road with a couple of bridges before spilling out into the River Kent. There are references to this being called 'Cock Beck' and being contained within a culvert down to the

Captain French Lane.

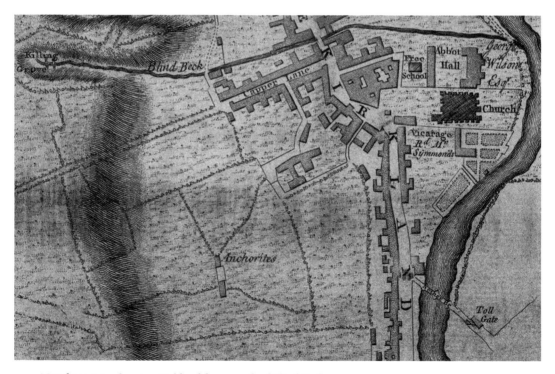

Map from 1770 showing Kirkland from south of Blind Beck.

Blind Beck divides Kirkland from Kendal.

Blind Beck is usually dry until there is heavy rain.

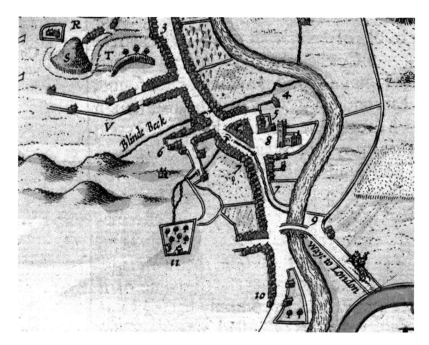

John Speed's map of 1611 showing 'Ankeriche' building and walled orchard or garden. Note the route of the spring through the town.

river. On the Jeffrey 1770 map it is shown isolated in fields with no beck whatsoever and two buildings. Wood's map of 1833 details a collection of buildings, an enclosure, and the beck running diagonally to Kirkland but disappearing before it reaches the town. By 1861 a map shows quite a substantial building and a lane leading to Kirkbarrow.

An anchorite is a hermit or recluse, usually secluded for religious reasons, devoting their life to prayer, meditation and good works. This strict life was embraced by both men and women, and it is believed women outnumbered men. This may have been due to medieval prejudices concerning women or perhaps simply because the amounts of religious positions available to women was more limited than for men.

Though not in this case, the cell, or reclusory, was usually a room that adjoins the parish church with a narrow window or 'squint' enabling the anchorite to view the altar. Another opening would allow the anchorite to converse with visitors and communicate with the outside world. Some of these cells or anchorite buildings would have several rooms and be endowed with gardens. The old maps of Kendal show a walled enclosure and this land must have enabled the resident to be self-sufficient.

One of the stories that have grown about a Kendal hermit is from around the time of the Reformation, when a Julien de Clifford left money to the parish church to say masses for his soul. He went to fight in the Crusades in the Holy Land and was guilty of murder, so to atone for his sin he joined the order on his return. An alternative story, and much more romantic one, is that a man who lost the love of a lady went off to on crusade to forget. When he returned he lived in a cell and used the water to cure leprosy and other diseases. It is said the well is fed by a spring that never runs dry and was thought to have healing powers.

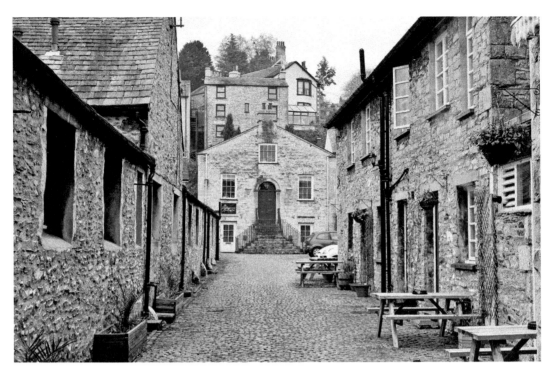

Shakespeare Yard with an old theatre with the purple door.

The old Moot Hall stood at the south-west corner of Kendal Market Place and was originally built around 1591/92, though greatly modified in 1759, including the addition of a clock turret. Originally used as the town hall, part market and court, many market towns built a moot hall ('moot' meaning an assembly held for debate, especially in Anglo-Saxon and medieval times). According to Cornelius Nicholson, it was 'a plain building for the purposes to which it was applied. It consisted of a court-loft, with ante-room for retiring juries, which being separated by partition slides, might be thrown together as necessity required. It is surmounted with a square tower, which contains a clock.' The building had fallen into 'dilapidation and disuse' before it was sold by auction in 1859 and it must be around this time the town clock was given to St Thomas's Church in Stricklandgate.

For many years the old Moot Hall was given over to retail and the home of Brunskill's the draper's, but in the 1960s it was the target of a deliberate arson attack. The building was replaced by a similar, but in many an opinion, poorer, facsimile. One of the old Venetian windows from 1759 was saved and can still to be seen on the western wall.

St Thomas' Church in Stricklandgate deserves a special mention because it is built back to front. Usually a church is built in the shape of a cross with the tower or spire at the west end. St Thomas' is built on a site called Fell Field, which was a particularly marshy area and because of this very poor ground, so the tower had to be built at the east end. Here the ground was much more solid and provided a much better foundation. Built in 1837 by the renowned Kendal architect George Webster, the church was later modified and also given the clock from the Moot Hall.

Above: Moot Hall.

Right: Moot Hall and Venetian window.

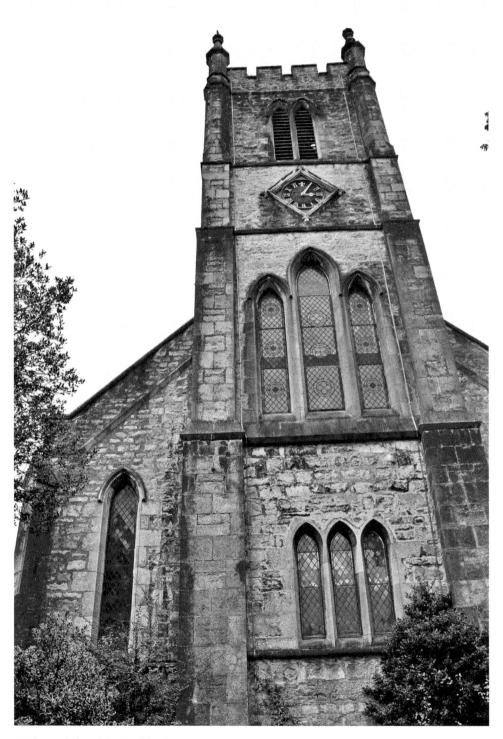

St Thomas' Church in Stricklandgate.

Monument House and the Scotch Burial Ground are located on Beast Banks behind Castle Howe. The house was originally built in 1764 as a Scottish Presbyterian chapel and connects to a burial ground, which was in use from 1763 until 1855. Due to a dwindling congregation, the chapel fell out of use by 1812 when the building was sold. The new owner, Edward Burton, an auctioneer, converted the chapel to a private house and added a summer house and coach house. In 1981 the building was converted into six flats and overlooks the historic monument to the Glorious Revolution on Castle Howe.

Dockray Hall is believed to have been a pele tower, surrounded by a wall and with an attached chapel dedicated to St Anne. This appears on Speed's map of 1610; later maps show a chapel and barn, but without the house. It is possible the barn was part of an old hall and survived until the twentieth century. The chapel was seen by Machel in the sixteenth century, by Nicolson and Burn in 1777, and by Curwen around 1900.

The site is now built over but looks to have been located to the west of Burneside Road around Ashleigh Road and Dockray Hall Road. It is believed the Dockray family were punished following the Civil Wars by the Commonwealth and their property sold off. This probably ended with the hall being stripped for materials and demolished for the stone. There are now no remains of any of the buildings, including the barn and church.

One of the more famous incumbents of the hall was Sir Thomas Docwra, who was the last Grand Prior of the English Order of the Knights of St John (1501–27). Records relating to the barony of Kendale mention him paying tithes in 1459 and being present at a wedding in

Scottish Burial Ground sign.

a memorandum of 1526. Thomas entered the order at the age of sixteen, and later in 1480 he was in Rhodes with Sir Thomas Greene during the unsuccessful Turkish siege of the island.

Sir Thomas Docwra was appointed Prior of Dinmore around 1486. This priory in Herefordshire was originally held by the Templars, but following their suppression in 1313 it passed to the Knights of St John (also known as the Hospitallers). On 6 August 1501 he was appointed Grand Prior of England. The position accompanied the post of premier baron of England and was used by both Henry VII and VIII. He was used by Henry VIII as his messenger and was one of the nobles who accompanied him to the meeting with the King of France at the Field of the Cloth of Gold in 1520.

Greenside Lime Kilns are located at Greenside on the old Ulverston Road, just east of Beast Banks. They are now preserved for the town by a combination of the South Lakeland District Council, the Lottery Heritage Fund, Kendal Town Council and the Kendal Civic Society. For more details of the kilns, be sure to take a look at the information boards at the site.

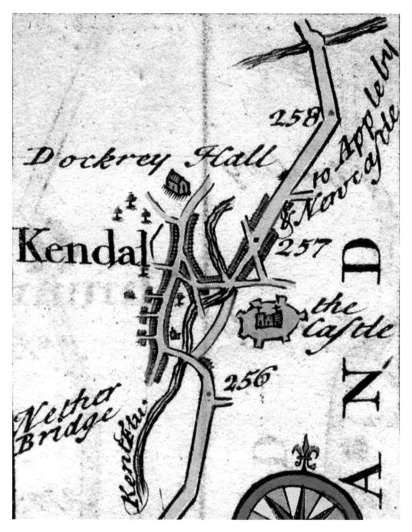

Map showing Dockwray Hall.

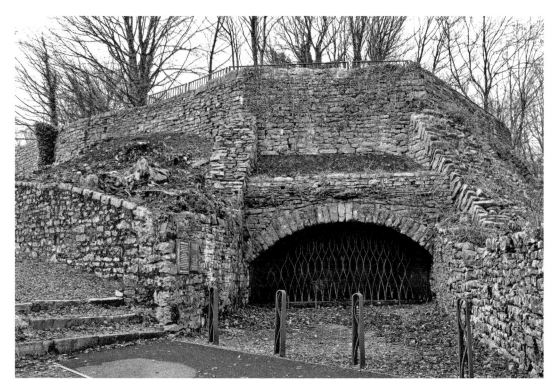

Greenside Lime Kilns.

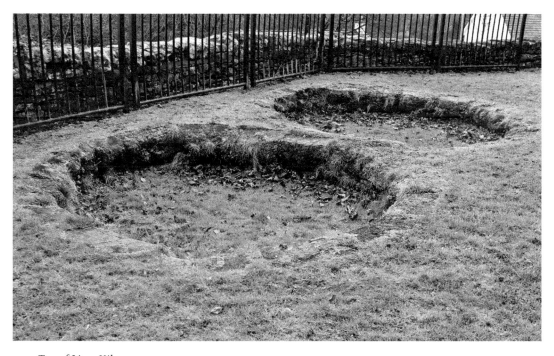

Top of Lime Kilns.

8. Festivals, Sports and Pastimes

Kendal Bowmen

There was a festival and competition held in Kendal on 9 September where the Kendal bowmen celebrated the ability of their predecessors. It was on the field of Flodden on this day in 1513 that the Kendal bowmen were so praised.

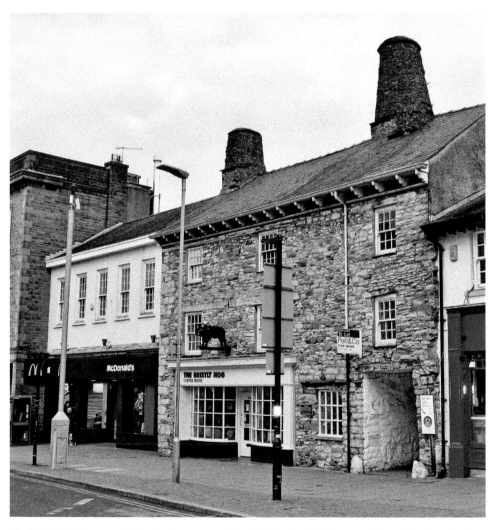

Black Hall built *c*. 1575. Note the large round South Lakeland Chimneys. Above the door is a hog with bristles down its back from the days when it was a brush factory.

An old poem called Flodden Field comments:

> There are the bows of Kendal bold,
> Who fierce will fight and never flee
> And the lusty Lord Dacres did lead
> With him the bows of Kendal stout.

The prizes included a silver arrow and a medal, with the bowmen appearing in a 'uniform of green, arrow buttons, the cape green velvet with silver arrow, the waistcoat and breeches buff, and the shooting jacket was of green and white striped cotton'.

Thomas Strickland was at Agincourt in 1415 and apparently he had with him a contingent of Kendal bowmen. This confirms a minimum service of over 200 years for the men of green – Kendal Green – in some of most celebrated battles in British history.

Piggin Bottoms

Oatmeal was used in the composition of pie crusts and gingerbread, as well as the famous Kendal 'piggin bottoms'. These were stamped out of the rolled dough by the iron rim, which formed the external base of the wooden 'piggin' or 'biggin', a small wooden tub used as a general container for household goods. Most of the houses had either no oven or a very small one, and baking was done in a huge iron pan with a massive lid.

DID YOU KNOW?
A 'Crowdy' was a soup made by pouring the juices from boiled beef over oatmeal in a bowl or basin.

Kendal Sports

Football must have been played in the streets of Kendal, probably in the same format as the 'Uppies and Downies' of Workington, but in Kendal the Corporation levied some rules:

> Whosoever do play at the football in the street and break any windows, shall forfeit upon view thereof by the Mayor or one of the Aldermen in the ward where the fault is committed the sum of 12d for every time, every party and 3s 4d for every window by the same broken and to be committed till it be paid.

It sounds as though a game of football could have become very expensive and perhaps not so dissimilar from today.

Knurr and Spell is a game played with a levered wooden trap that throws a knurr into the air. The knurr is around the size of a walnut and is struck by the player with the spell. The spell is a bat a little like a golf club, and the objective of the game is to hit the

knurr the greatest possible distance. The game was popular in Yorkshire. Some rules of the game in Kendal in 1657 are:

> It is ordered by the Court that all such persons, inhabitants within this borough, above the age of twelve years, that hereafter shall play in the streets at a game commonly called Kattstick and Bullett shall forfeit and incur the penalty of 12d for every offence, to be levied of their goods, and where they have no goods to be imprisoned two hours.

Beers Festivities

One of the festivities mentioned from the past is the Levens Radish Feast. In the time of Colonel Grahme (late seventeenth century) there was great rivalry between the houses of Dallam Tower and Levens. When Dallam Tower invited every person who attended Milnthorpe Fair to partake of the good cheer provided in the park, a piece of hospitality which irritated the Colonel very much. As a result, the following year, when the mayor and Corporation of Kendal went to proclaim the fair, he took them to Levens and provided such splendid entertainment that the Corporation gladly accepted the invitation

Farrer old shopfront.

for the succeeding years. The ladies were strictly barred from the proceedings, where long tables were placed on the bowling green and spread with oat bread, butter, radishes and 'morocco' – a kind of strong beer, for which the hall was famed. After the feast there was some japery with the visitors, and various amusements that are described as 'better to read about than witness'.

Morroco Beer was revived for the 300th anniversary of the Levens Hall Gardens in 1994. Brewed to a secret recipe, this strong dark beer had a hint of spices and is said to be a 'good choice when eating curry or other strongly favoured foods'. Morocco Ale is specially brewed for Levens Hall by Daleside Brewery and has won many prizes over the years including a 2003 CAMRA silver medal.

Nut Monday

At one time the humble nut was extremely important to Kendal, and was deserving of a special day in mid-September called Nut Monday. The day was a general holiday with shops and schools being closed to celebrate the nut harvest. Apparently held as late as 1861, Nut Monday may have ended due to the failure of the nut crop in several successive years and the day losing its distinctive character.

Nut Monday should not be confused with Crack-Nut Sunday, a strange event held on the last Sunday before Michaelmas (29 September). This is an old English name for a custom where the congregation brought nuts to the parish church and cracked them during the service. The congregation would crack nuts during the sermon and drown out the words of the priest.

Cockpenny

A 'cockpenny' was the name for payment made by each boy of the school on Easter Tuesday and was to be used to enable the schoolmaster to provide the pupils with a cockfight. One of the regulations for Kendal School was that it should be 'free to all boys resident in the parish of Kendal, for classics alone, excepting a voluntary payment of a cockpenny as a foretime at Shrovetide'.

A series of papers submitted to the *Kendal Chronicle* in 1812 commented:

A stranger to the customs of the country will suspect something whimsical in this name, but it has its foundation in reason; for the boys of every school were divided into parties every Shrovetide, headed by their respective captains, whom the master chose from among his pupils … these juvenile competitors contended in a match at football, and fought a cock-battle, called the captains' battle, in both which contests the youthful rivals were not more interested than their parents.

Though the cruel sport of cockfighting died out, the payment of a cockpenny survived until the middle of the nineteenth century. Evidenced by a Mr W. Sayer in 1847, who comments: 'the endowments of Bowness (Westmorland) School, together with a cockpenny given by each scholar on Shrove Tuesday, amounted to about £60 per annum.'

For information around the town, also refer to the informative plaques at historic points placed by the Kendal Civic Society.

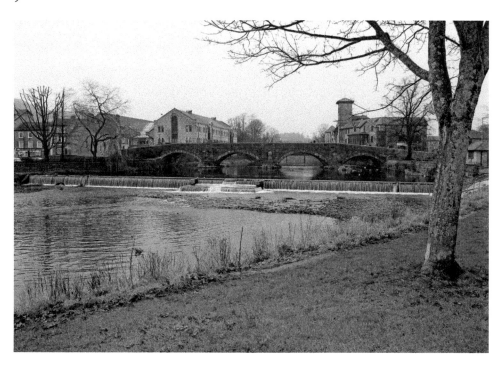

Above: Stramongate Bridge from Gooseholme.

Left: Collin Croft Yard halfway down Beast Banks.

The war memorial in Market Place.

Town Hall.

About the Author

Andrew Graham Stables has had a keen interest in history since he was given a *Children's Encyclopaedia of British History* in 1971 by his grandparents. He studied History at Teesdale School Sixth Form, has a diploma in Project Management, and is a member of English Heritage as well as a regular contributor to several online local history groups. He has worked in the mechanical and electrical building service industry for over thirty years and has been involved in a large number of major construction projects throughout the country. Originally from Barnard Castle, and now living in York, Andrew is also working on a history of the ancient route over the Pennines known as the Stainmore Pass, or the A66. His previous work includes *Secret Penrith* (Amberley Publishing, 2016).

Acknowledgements

Thank you to all the people who have assisted me during the writing of this book including my wife Gillian and son Harry, who took some of the photographs. Also thanks to the team at Amberley Publishing. Special thanks go to Matthew Emmott for the use of a couple of photographs and the people of Kendal, who have been kind and friendly on all of my visits to the town.

Select Bibliography

Collingwood, W. G., *Three More Ancient Castles of Kendal* (1907).

Cox, Thomas, *Magna Britannica et Hibernia, Volume 6: Westmorland* (1731).

Nicholson, Cornelius, *The Annals of Kendal* (1861).

Parson, W. M. and White W. M., *History, Directory and Gazetteer of the Counties of Cumberland* and Scott, Daniel, *Bygone Cumberland and Westmorland* (1899).

The Mysterious Musings of Howard Bell, a Workington Lad, Born and Bred, self-published.

White, Andrew, *A History of Kendal* (Carnegie Publishing Ltd, 2013).

www.britishlistedbuildings.co.uk/england/cumbria/kendal

www.visitcumbria.com

www.bitaboutbritain.com

www.matthewpemmott.co.uk

www.british-history.ac.uk

www.cumbria-industries.org.uk

www.kendalcivicsociety.org.uk